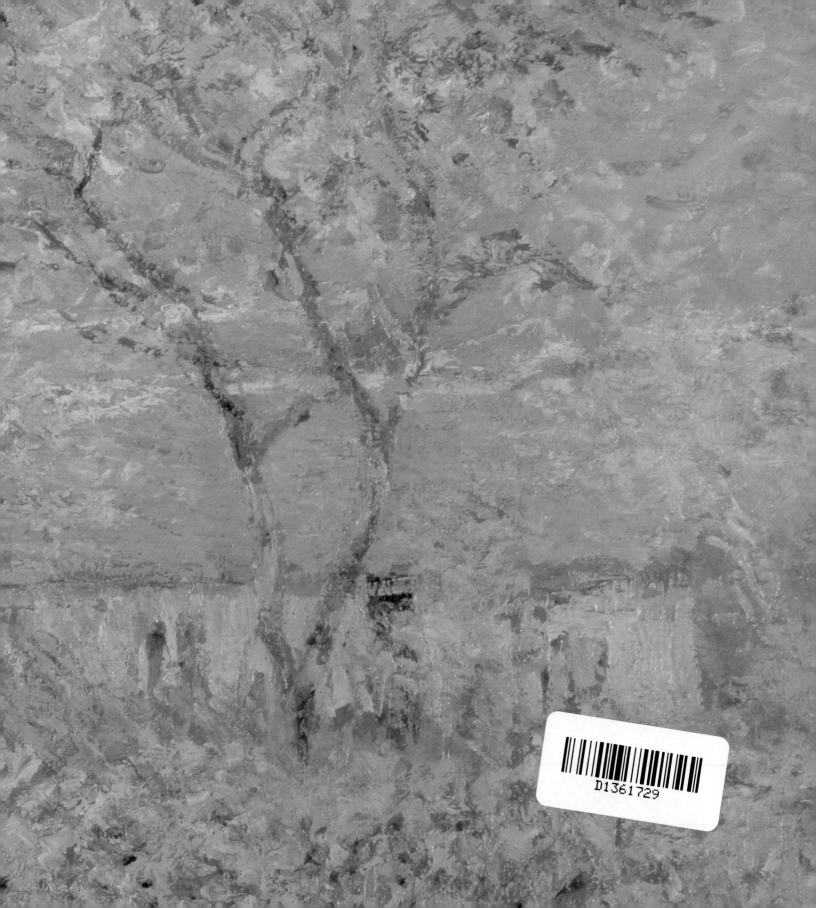

images of

IMPRESSIONISM

DIANA CRAIG

Published by
Laurel Glen Publishing
5880 Oberlin Drive, Suite 400
San Diego, CA 92121-4794

First published in 1999 by Hamlyn, an
imprint of Octopus Publishing Group Ltd,
2–4 Heron Quays, London E14 4JP

© Octopus Publishing Group Limited 1999

Publishing Director Laura Bamford
Executive Editor Mike Evans
Editors Humaira Husain, Michelle Pickering
Creative Director Keith Martin
Senior Designer Geoff Fennell
Picture Research Wendy Gay
Production Controller Joanna Walker

North American Edition
Publisher Allen Orso
Managing Editor JoAnn Padgett
Associate Editor Elizabeth McNulty

ISBN 1-57145-643-0

Library of Congress Cataloging-in-Publication
Data available upon request.

Produced by Toppan Printing Co Ltd

Printed in China

Details of illustrations on pages 16-17,
32-33, 48-49, 64-65 and 80-81 can be
found on pages 94 and 95.

Monet NYMPHEAS 1907

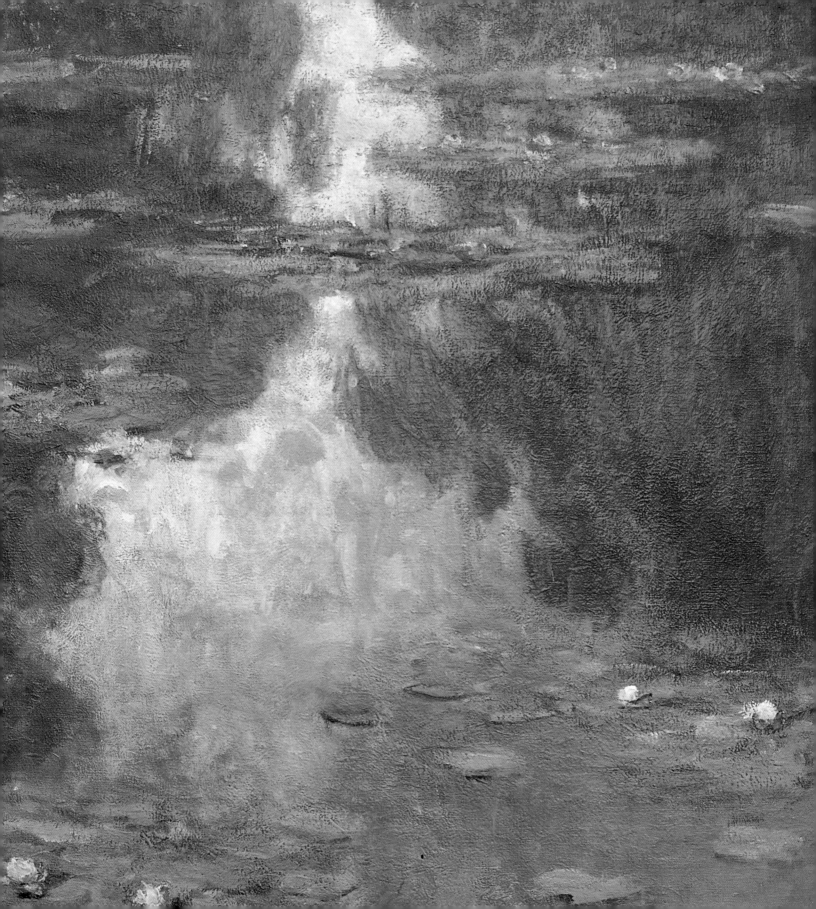

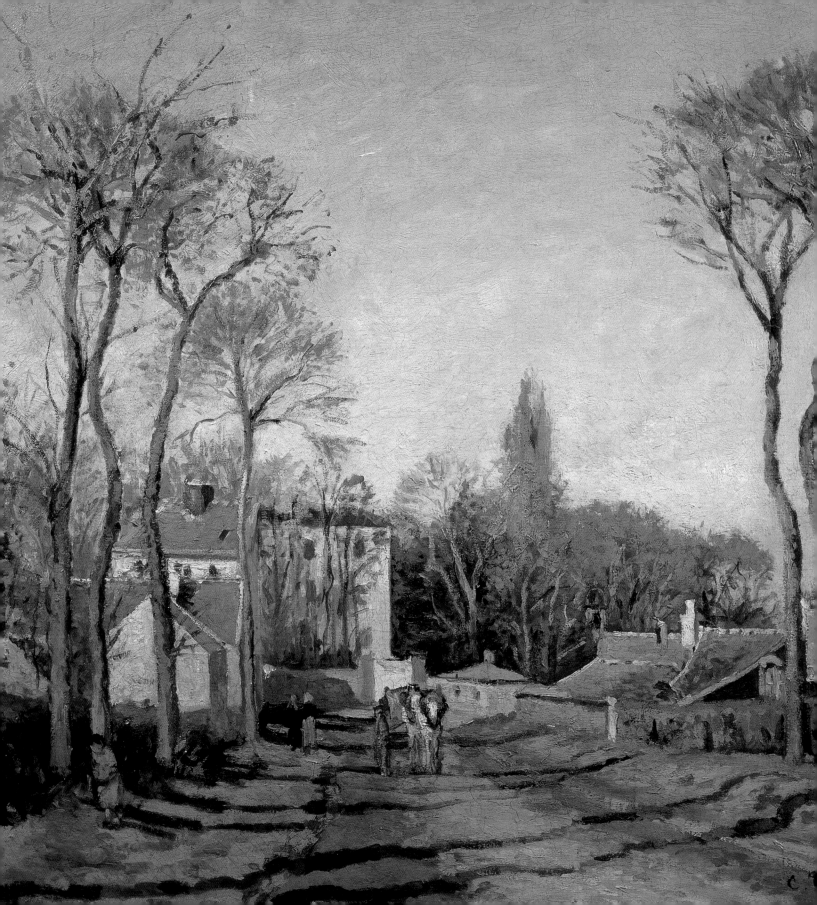

Pissarro ENTRY TO VILLAGE OF
VOISINS, YVELINES 1872

INTRODUCTION

The name "Impressionism" was invented as a term of abuse, an insult hurled by a critic after seeing the Monet painting IMPRESSION: SUNRISE at an exhibition of works by a new group of artists in 1874. Some 165 works were on show, but neither critics nor public were at all impressed—indeed, many came there to laugh. People joked that the artists had fired paint at their canvases from a pistol, and then finished with a signature; others described the works as "wallpaper" and brushmarks as "black tongue-lickings."

The most famous members of the group that so upset public ideas of what art should be were Monet, Renoir, Sisley, Pissarro, and Morisot, with Manet as their mentor. Closely associated, too, were Degas and Cassatt. Cézanne, a contemporary, also exhibited with them. But what was it in the climate of the 1860s that conspired to make this particular period so ripe for an explosion of new and radical artistic ideas?

One factor was a change in the way artists worked. The old craft-based system whereby technical expertise was passed down from master to apprentice was long gone, replaced by academic teaching that involved conventions that had become rigid and meaningless. In addition paints, once mixed by the apprentices, were now manufactured commercially and were different in character from those formerly used, further distancing artists from a practical knowledge of their craft and requiring that they paint in a different way.

Another development that demanded a new role for art was the invention of photography. It was now possible to achieve with a mechanical device what previously had been created by paint on canvas, paper, or wood. Photography liberated art from the need for figurative literalism, and allowed it to explore new ways of depicting the visible world.

Finally, there was the Japanese print. In eighteenth century Japan, artists such as Utamaro (1753–1806), Hokusai (1760–1849), and Hiroshige (1797–1858) had themselves bravely broken with a thousand-year-old tradition that had grown out of Chinese art, and had begun to depict scenes of ordinary life in their woodcuts. These boldly colored prints defied all the rules of composition that underpinned European academic art. Mount Fuji might be glimpsed through the curl of a wave, for example, or figures were cut off by the edge of the paper or a screen. Scorned in their native land, these prints were used as wrapping or padding in trade goods, such as tea, that arrived in Europe from Japan. In this way, they came into the hands of European artists and, like a blast of fresh air, offered them a totally new vision of what art could be.

Out of all these different influences came the need for a new kind of art, free of the worn-out clichés of academic tradition.

In Paris, the battle lines between traditional and new were drawn when, in 1863, the jury of the official Salon rejected three-fifths of the 5,000 paintings sumitted for exhibition. The

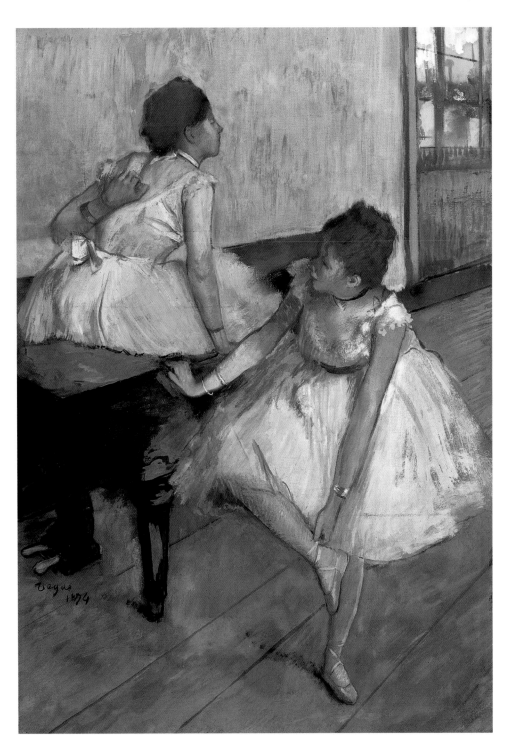

Degas TWO DANCERS RESTING 1874

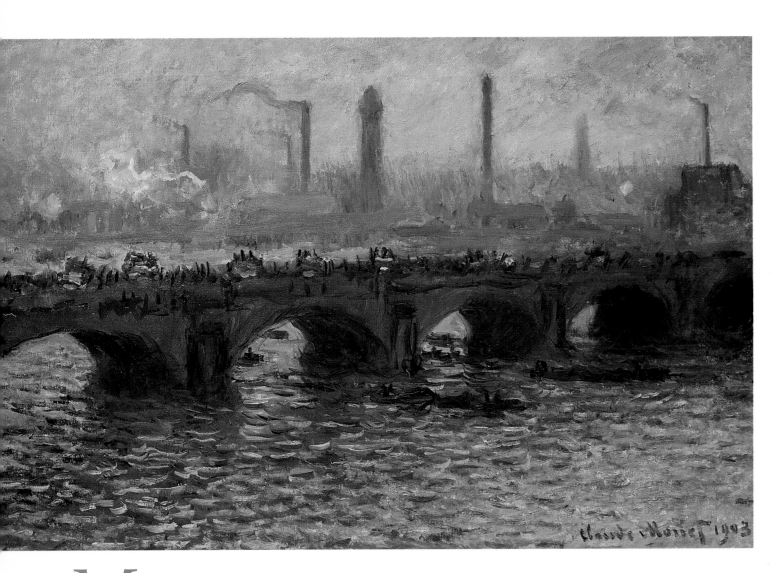

Monet GRAY SKY, WATERLOO BRIDGE 1899/1901

8 INTRODUCTION

furor that ensued resulted in an alternative exhibition, the Salon des Refusés, being mounted for the rejected works, which included paintings by Manet, Pissarro, Cézanne, and Whistler.

Edouard Manet (1832–83) had now become the leader of a revolutionary new group of artists who no longer wished to be bound by the artificial constraints laid down by the art establishment and were searching for a new concept of art. These artists wanted to paint what they saw, not what they knew (or had been taught to know)—and that meant painting from nature in the open air, not from models or in the studio; it meant capturing the initial, fleeting impression of a scene, rather than slavishly painting every detail; it meant abandoning the technique of gradual shading of muted tones from light to dark, and allowing for harsh contrasts and colored shadows. The new realism these artists sought also meant that any subject, however ordinary, was a candidate for the painter's brush, not just the "dignified" subject matter previously deemed suitable.

Realizing that they would not receive official recognition and calling themselves the Anonymous Cooperative Society of Painters, Sculpters, Engravers, etc. the group decided in 1874 to put on their own show at 35 Boulevard des Capucines in Paris. There were 30 participants. The show lasted for a month, from April 15 to May 15. It was here that "Impressionism" was born.

Of course, the paintings on show revealed such a radical departure from accepted ideas that they were seen as heretical, and the Impressionists' techniques were damned as slapdash. Subsequent group shows, of which there were seven, fared little better. After the second exhibition, a critic compared the Impressionists to lunatics from Bedlam who had mistaken stones on the road for diamonds. Thus began a battle that would last for many decades and would become legendary in the history of art, another example of how innovators are often initially misunderstood by the public.

Despite derision, hostility, and, in some cases, appalling financial hardship—Monet, for example, had no private income to back him up—the Impressionists soldiered on, staying true to their ideals. For some, there would be the gradual dawning of widespread recognition and success during their lifetimes. Others, sadly, died unrecognized, their works selling for high prices only posthumously.

With the deaths of Monet and Cassatt in 1926, the last of the core group of Impressionists had gone, but their legacy to succeeding generations of artists cannot be overestimated. The ripples of their innovative vision have been felt through all the years since. They impressed and influenced such abstract painters as the Russian Vassily Kandinsky (1866–1944) and even anticipated the Abstract Expressionists like the American Jackson Pollock (1912–1956). Straddling the end of one century and the beginning of another, they gave the world the gift of a brand new way of seeing.

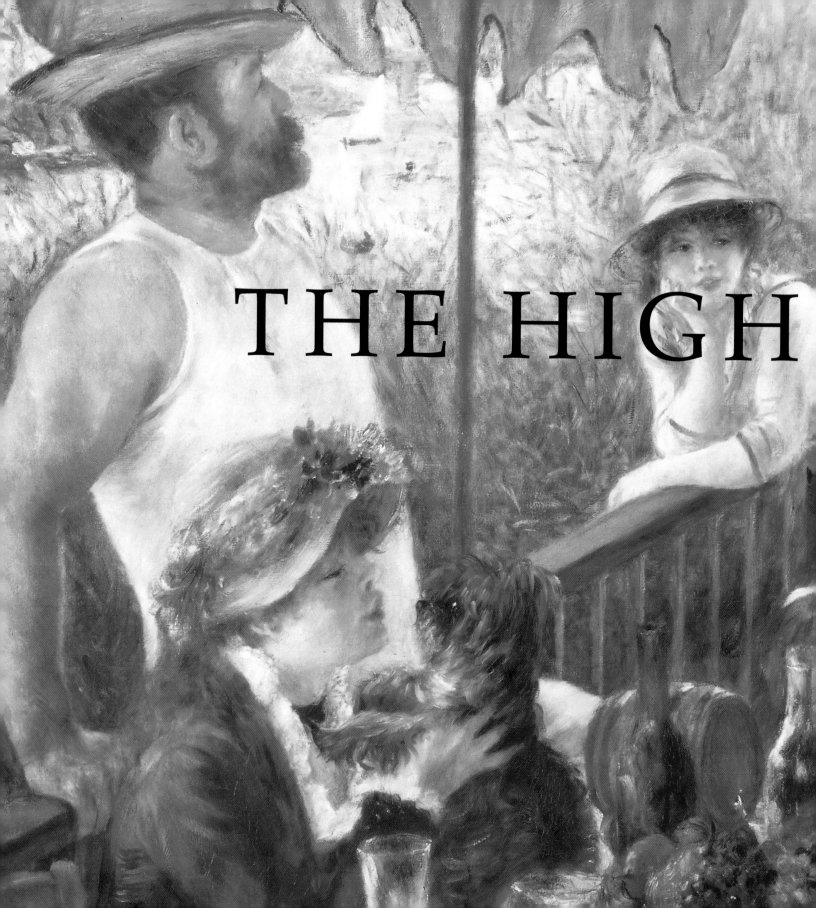

THE HIGH

LIFE

Renoir
THE LUNCHEON OF THE BOATING PARTY 1881

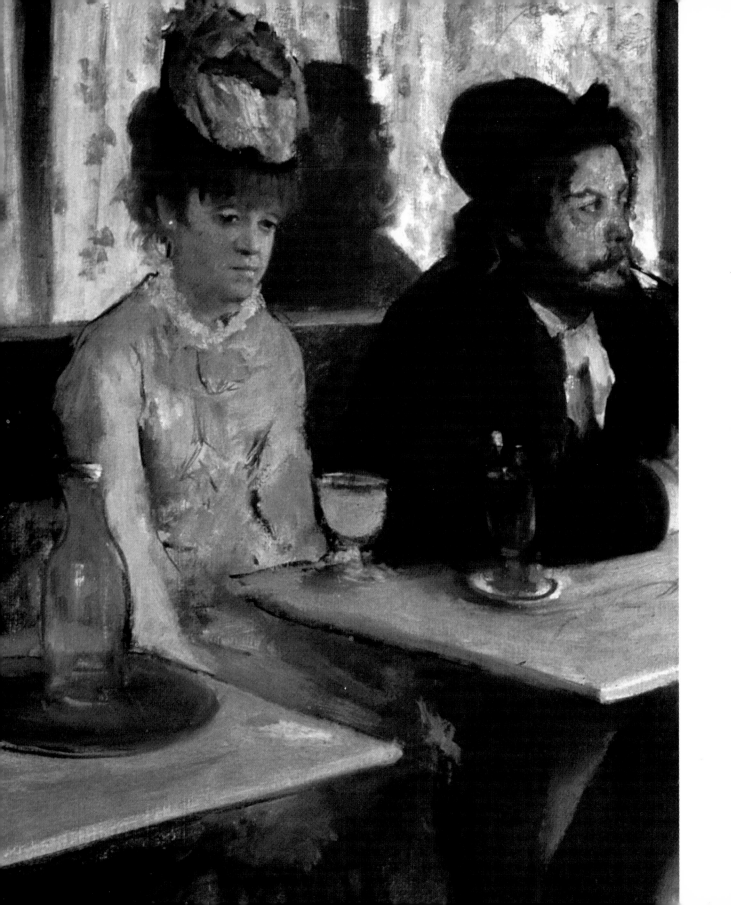

CAFÉ SOCIETY.

The cafés of Paris have always been a magnet for artists, writers, and intellectuals—a meeting place where new ideas can be explored. The crucible of Impressionism was the Café Guerbois on Grande Rue des Batignoles (later Avenue de Clichy). It was here, between 1869 and 1873, that artists and others interested in a new aesthetic came together for an exchange of views, under the leadership of Manet. Regular meetings took place at the tables there every Thursday evening, but it was visited at other times as well by Degas, Renoir, Sisley, Pissarro, and Cézanne, to name but a few. "Nothing could be more interesting than those causeries with their perpetual clash of opinions," Monet later recalled. "They kept our wits sharpened, they encouraged us with stores of enthusiasm that for weeks and weeks kept us up, until the final shaping of the idea was accomplished. From them we emerged with a firmer will, with our thoughts clearer and more distinct."

Later, when the group had become more dispersed, a few still continued to meet, but at the Café de la Nouvelle-Athènes, in the Place Pigalle in Montmartre, a quieter neighborhood than that of the Guerbois.

Inevitably, scenes from these and other cafés and bars found their way into many Impressionist paintings and drawings. One such is the famous ABSINTHE, painted by Degas in 1876, which conveys the seedier side of café life. In ABSINTHE, the French actress Ellen Andrée poses with the artist Marcellin Desboutin in the Nouvelle-Athènes, a glass of the deadly brew before her (absinthe can be as much as seventy percent alcohol and formerly contained oil of wormwood, which attacks the nervous system and is now banned).

Degas ABSINTHE 1876
(above and detail opposite)

13

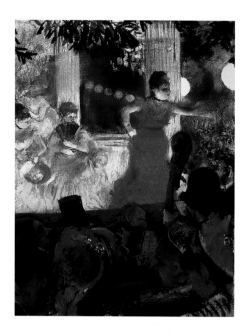

Degas CAFÉ-CONCERT AT THE AMBASSADEURS 1876–77

MUSICAL ENTERTAINMENTS

The so-called "café-concerts" and the music hall were one aspect of Parisian nightlife that certain of the Impressionists liked to include in their pictures. Among examples of the genre are CAFÉ-CONCERT AT THE AMBASSADEURS, painted by Degas in 1876–77, and, of course, one of the most famous of all the Impressionist paintings, THE BAR AT THE FOLIES-BERGÈRE, painted in 1881 by Manet, late in his career. The focus of the latter is the now-familiar figure of the young barmaid staring out vacantly past the viewer. However, by means of a clever device—a mirror in the background—Manet allows us to see much more. In its reflection, we see what she sees: a smartly dressed gentleman by the bar, and behind him a scene that sparkles with big chandeliers and bright lights, and is filled with people. Yet the detached, world-weary, and even sad expression on the young woman's face belies the implied excitement of the scene, and leads us to wonder who she was and what her life might have been like.

If the barmaid was bored by what she saw, the public were no more impressed when they first saw the painting in 1882. This was the Folies-Bergère, a music hall that featured striptease acts and was a haunt of prostitutes. Manet's choice of contemporary and unconventional subject matter was what the public noticed, rather than the artistry involved—artistry achieved at great cost to the painter himself, who by this time was suffering from locomotor ataxy (a degenerative disease that affects muscular coordination) and would die a year later.

14

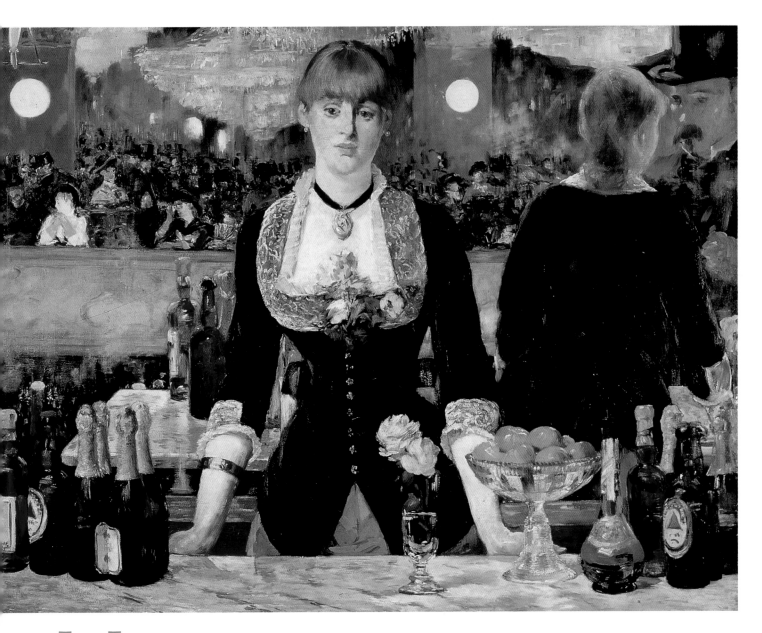

Manet THE BAR AT THE FOLIES-BERGÈRE 1881

THE HIGH LIFE 15

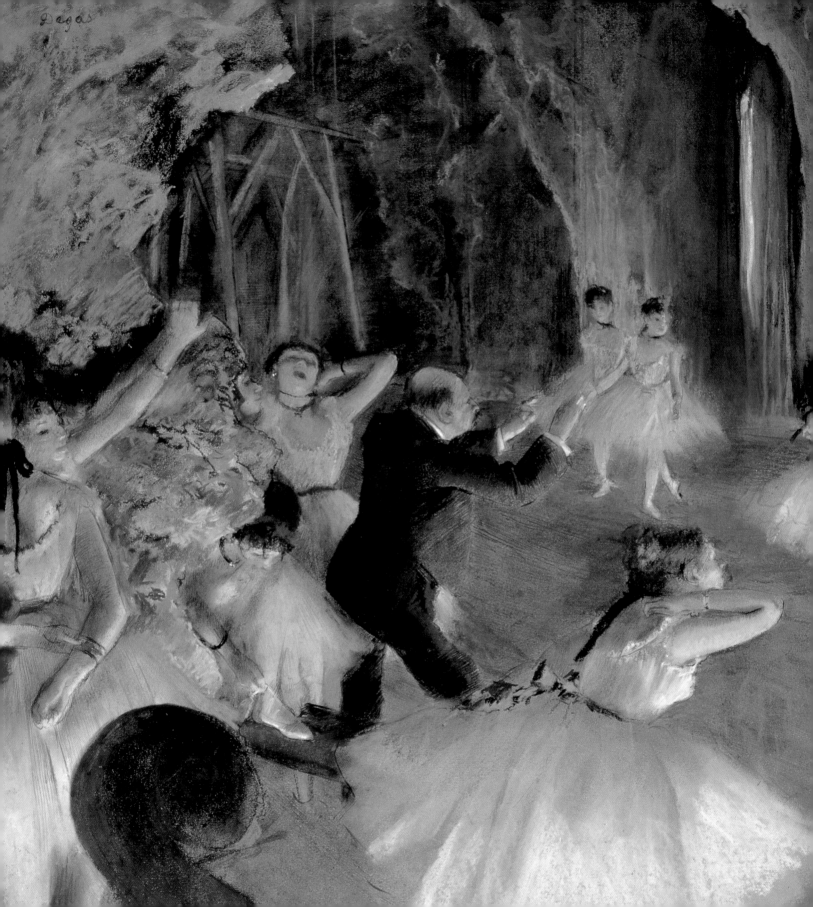

Edgar Degas
1834–1917

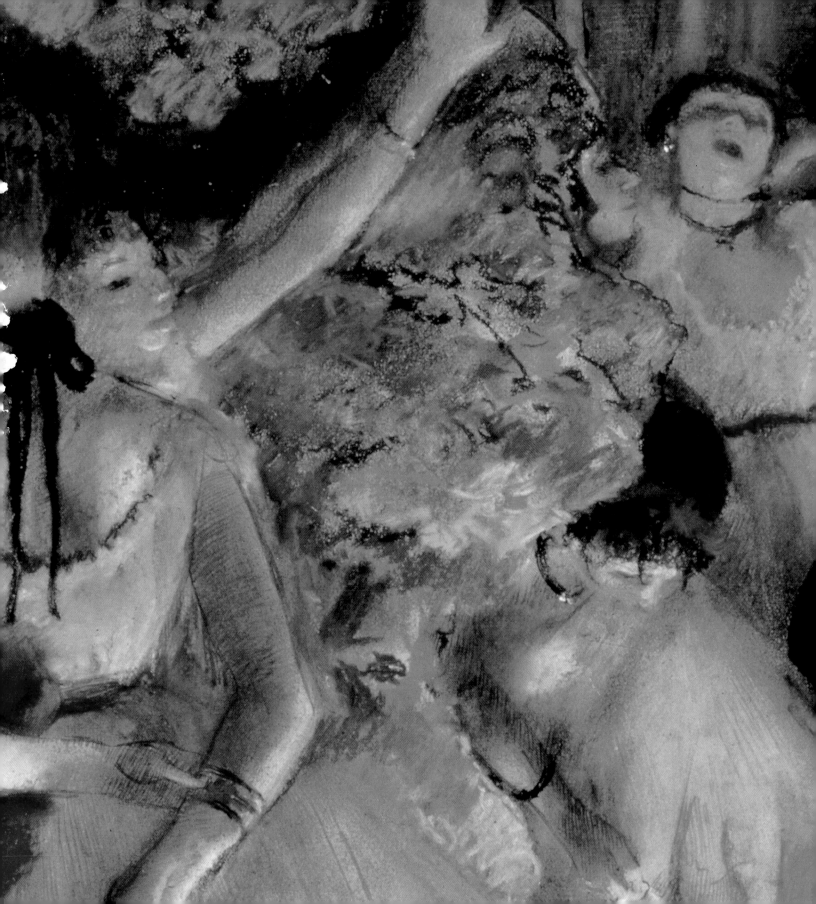

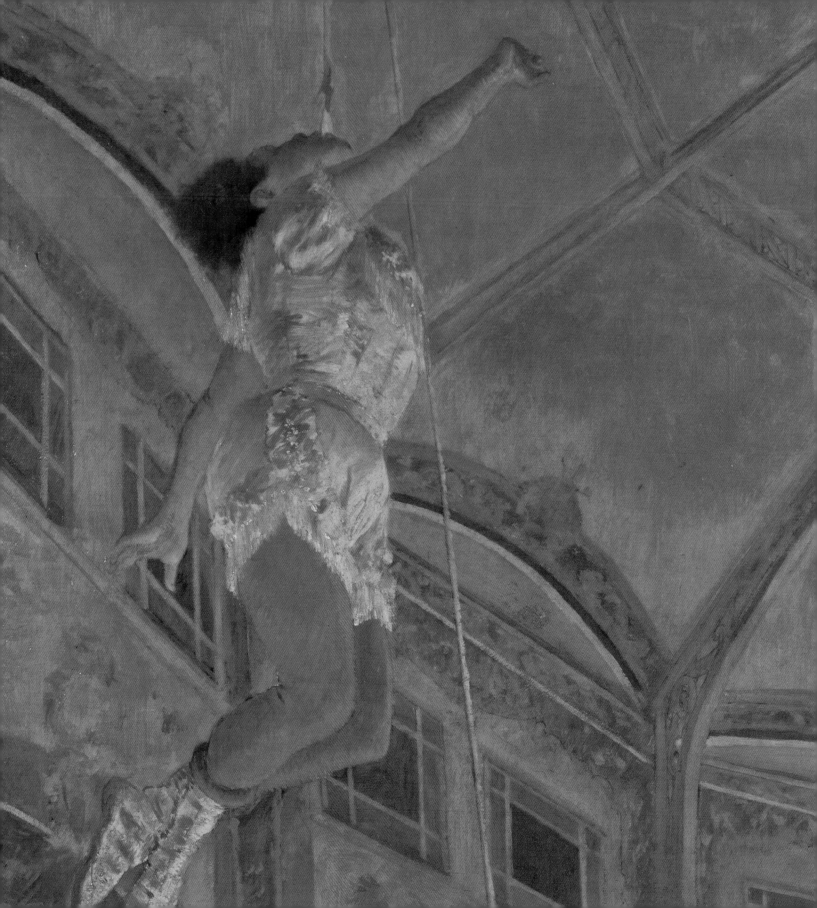

Degas

MISS LA LA AT THE CIRQUE FERNANDO 1879 (below and detail opposite)

THE "DEMI-MONDE"

Perhaps more than any other artist associated with Impressionism, Degas was a great chronicler of contemporary city life. Not for him the glories of nature, the simple honesty of peasant toil, or even the elevated subjects of myth, history, and religion. What he wanted was artificial life, not natural life, as he once told an Impressionist landscape painter, and what drew his artist's eye was a particular section of Parisian society known as the "demimonde," or "halfway world." In the second half of the 19th Century, Paris was an opulent, decadent, and highly sophisticated city, serviced by the inhabitants of this demimonde—barmaids, waitresses, laundresses, shopgirls, musicians, singers, dancers, and, of course, prostitutes, of which there were around 34,000 in Paris in the 1850s.

In addition to his familiar scenes of café life, Degas was attracted by the circus and, in particular, by a Miss La La, of whom he made numerous studies. The lady in question was a mulatto circus performer who stunned Paris when she appeared at the Cirque Fernando in January 1879. Her extraordinarily strong teeth and jaw muscles allowed her to hold a canon on a chain between her teeth while hanging from a trapeze, and earned her the nickname of La Femme Canon.

Having acquired his raw material, Degas then used it as a basis for his experiments in composition, as can be seen in MISS LA LA AT THE CIRQUE FERNANDO, painted in 1879.

19

Cassatt
WOMAN IN BLACK AT THE OPERA 1880

WATCHING YOU WATCHING ME

Impressionism held up a mirror to Parisian society, and reflected it faithfully back to itself. Almost nothing escaped its observant eye, and no activity was too trivial, frivolous, or ordinary to turn into subject matter for a painting. One popular Parisian pastime was going to the theater, which the fashionable attended not so much to see the performances on stage as to observe each other. Like scientists studying human behavior, both Renoir and Cassatt turned their artist's eye on these people-watchers of the auditorium and recorded what they saw, Renoir producing his famous THE THEATRE BOX (LA LOGE) of 1874, and Cassatt her WOMAN IN BLACK AT THE OPERA of 1880 and her own LA LOGE of 1882.

It is interesting to compare the first pair of paintings both of which depict members of the audience who observe each other through opera glasses. Renoir's painting was shown at the first Impressionist exhibition at 35 Boulevard des Capucines, the group having formally named itself the Société Anonyme Coopérative d'Artistes-peintres, Sculpteurs, Graveurs, etc. (the Anonymous Cooperative Society of Artist-painters, Sculptors, Engravers, etc.). Painted in Renoir's typically soft, rather "fluffy" style, it confronts the viewer, but in the gentlest way. With its strong, flat tones and angular forms, Cassatt's painting is much more assertive and even voyeuristic; while the woman in black focuses her attention on someone out of the frame, she herself is being watched by a man a few boxes along—and we, as viewers, watch both of them.

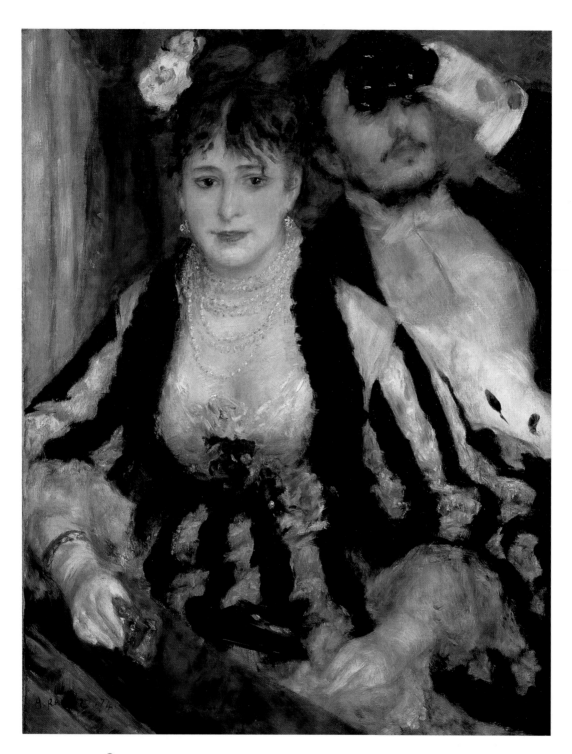

Renoir THE THEATRE BOX 1874

21

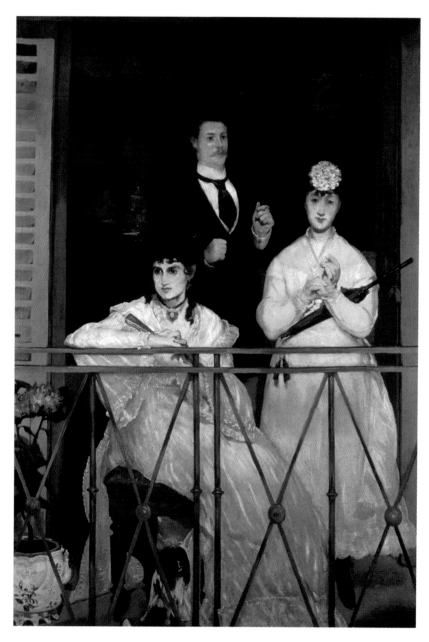

Manet THE BALCONY 1868

22 THE HIGH LIFE

ALL IN THE FAMILY

Finding sitters for his paintings must have been something of a problem for Manet, for he disliked professional models, yet critical hostility toward his work made him fearful of asking nonprofessionals to pose for him. However, a young woman was to enter his life who would become not only one of his regular models—attended by her mother, of course, for the sake of propriety—but also an accomplished Impressionist in her own right. This was Berthe Morisot, the daughter of a rich magistrate who, with her sister Edma, had taken up painting under the guidance of Corot and others.

In 1868 Manet asked her to pose for THE BALCONY, inspired by Goya's MAJAS ON A BALCONY. In the painting, the 28-year-old Morisot can be seen seated and, we assume, indulging in that most favorite of Parisian pastimes, people-watching. Given its provenance, however, the scene may be read less innocently, for the majas on Goya's balcony were certainly women "of easy virtue." The "maid" in attendance in this picture was in fact the violinist Jenny Claus, and the man behind was the painter Antoine Guillemet.

Morisot would pose for Manet again and he, in turn, would help her by retouching her portrait of her mother and her sister Edma, LA LECTURE. In 1874, Morisot strengthened the connection still further when she married his brother Eugène, becoming Manet's sister-in-law.

Morisot
LA LECTURE 1869–70

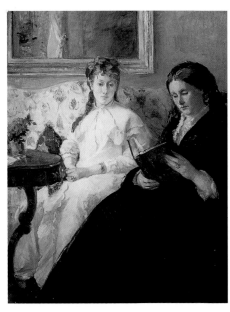

23

EVERYDAY TASKS

In their quest for realism, the Impressionists eschewed the posed portrait, the religious narrative painting, the idealized, the academic, and the classical, and showed instead real people doing the most ordinary, everyday things. Degas' work is an especially good example of this, for it includes such subjects as women trying on hats, waitresses serving drinks, laundresses at work (including one yawning), women in or out of the bathtub, even a woman having a pedicure—and, of course, there are his famous dancers, shown not as the ethereal ballerinas of the stage, but as the young women who put in hours of hard, physical work behind the scenes.

Despite its humble subject matter, Degas' paintings and drawings show profound artistry. Perhaps more than any of the others in the group, he was influenced by the compositional style of the eighteenth-century Japanese printmakers such as Hiroshige. This can be seen in his "off-center" placing of objects within the picture space, and in the then-revolutionary way in which he cropped his composition, sometimes lopping off a crucial part, such as the top or side of a subject's head.

Degas also had a solid grounding in his craft, which shows in his sturdy sense of form and strength of line. An ardent admirer of the French painter Ingres, Degas later recalled the advice that he, as an aspiring painter, received from the master. "It is very grave, what you are thinking of doing," Ingres warned him, "very grave indeed; but if you absolutely insist on being an artist, a good artist, well sir, make lines, nothing but lines."

Degas AFTER THE BATH, WOMAN DRYING HERSELF c.1890–95 (opposite);
THE PEDICURE 1873 (above)

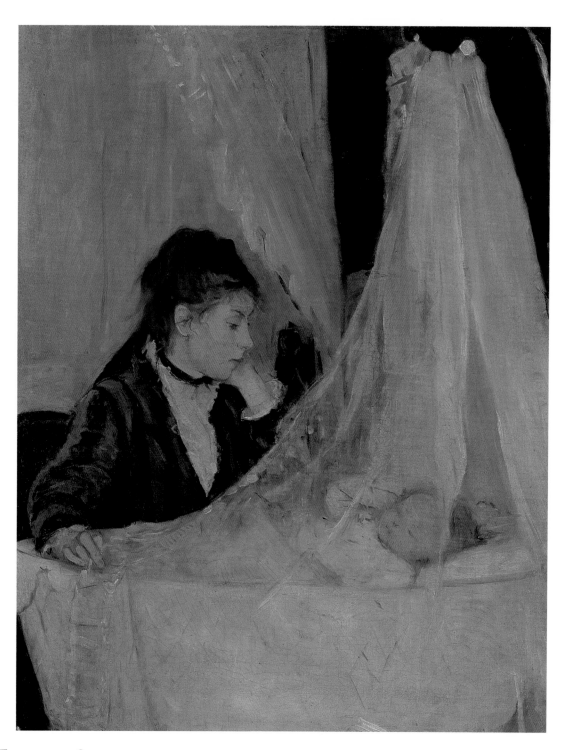

Morisot THE CRADLE 1872

A WOMAN'S PLACE

While society allowed male artists access to a wide range of subject matter—they could visit cafés and bars freely, they could work from live models both in teaching studios and in their own studios—women artists from middle-class backgrounds, such as Berthe Morisot and Mary Cassatt, were confined by the social restrictions then imposed on their sex. If it were not acceptable for a woman simply to be alone in a room with a man to whom she was not related, then working from a male model—even a fully clothed one—was totally unthinkable.

Restrictions such as these explain the predominantly domestic content of the work of these two artists. At first acquaintance with their paintings, we might think that they chose to depict mothers with children, or women engaged in quiet tasks such as sewing or sitting reading a book, because, as women, such subjects were of particular interest and relevance to them. In fact, they probably had little choice about what they could show. Their circumscribed position as women struck Cassatt especially, so much so that she came out in public support of the fight for suffrage in her native country of America.

The danger with such subject matter, especially where it involves mothers and their babies, is that it can quite easily descend into sentimentality. It is a tribute to the artistic skill and commitment of these two women—Cassatt with her broad, decisive brushstrokes and flattened forms, and Morisot with her characteristically feathery flashes of paint—that they did not fall into this trap.

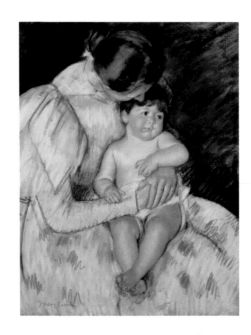

Cassatt MOTHER AND CHILD 1893

27

A BREATH OF

Claude Monet

Monet

WILD POPPIES NEAR ARGENTEUIL 1873

FRESH AIR

DAPPLED LIGHT AND SHADE

When Renoir moved from his studio on the Rue St. Georges in Paris to a small house on Rue Cortot in Montmartre, he acquired more than just a roof over his head and a place to work. The house came with a large garden—in fact, it was an abandoned park—that gave the new tenant plenty of opportunity for *plein air* (open air) painting. It was here, in the garden at Rue Cortot in 1876, that he painted THE SWING (LA BALANÇOIRE). Although at first glance a figure painting, that clearly is not the painting's real purpose. During this period, Renoir was especially preoccupied by the flickering effects of dappled light and shade, and placing his models under trees allowed him to explore the way in which light filtered through the leaves, spattering skin and clothing, and subtle greens were reflected from the foliage. The white dress, due to its reflective surface, provided the perfect vehicle for such explorations.

Not far from Renoir's home in the Rue Cortot were the grounds of an old mill, the Moulin de la Galette, a popular dancing venue for Parisians. They offered Renoir the ideal opportunity to put into practice two of the key principles of Impressionist art—painting outdoors and showing scenes from modern life. The work that Renoir produced as a result of his visits to the mill was LE MOULIN DE LA GALETTE, dating from 1876 (there are in fact two versions of this painting). As in THE SWING, we again see Renoir's fascination with the effects of dappled light and shade, especially on the men's boaters, the women's pale dresses, and the ground itself.

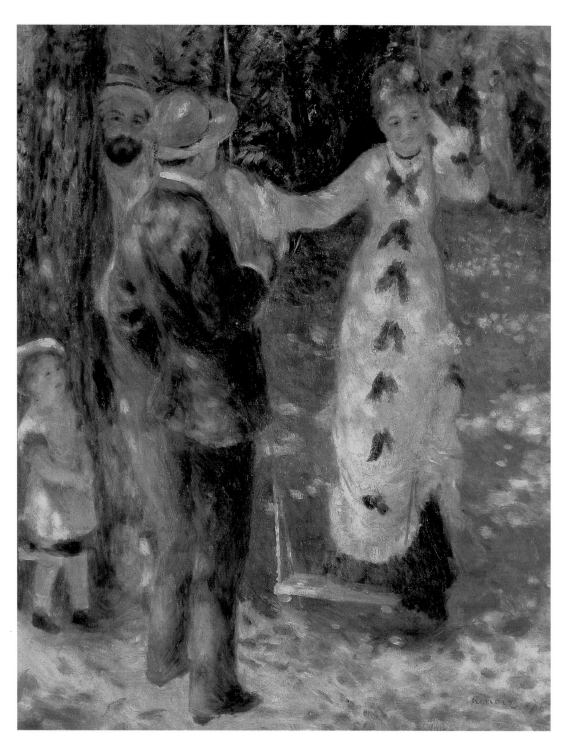

Renoir THE SWING 1876

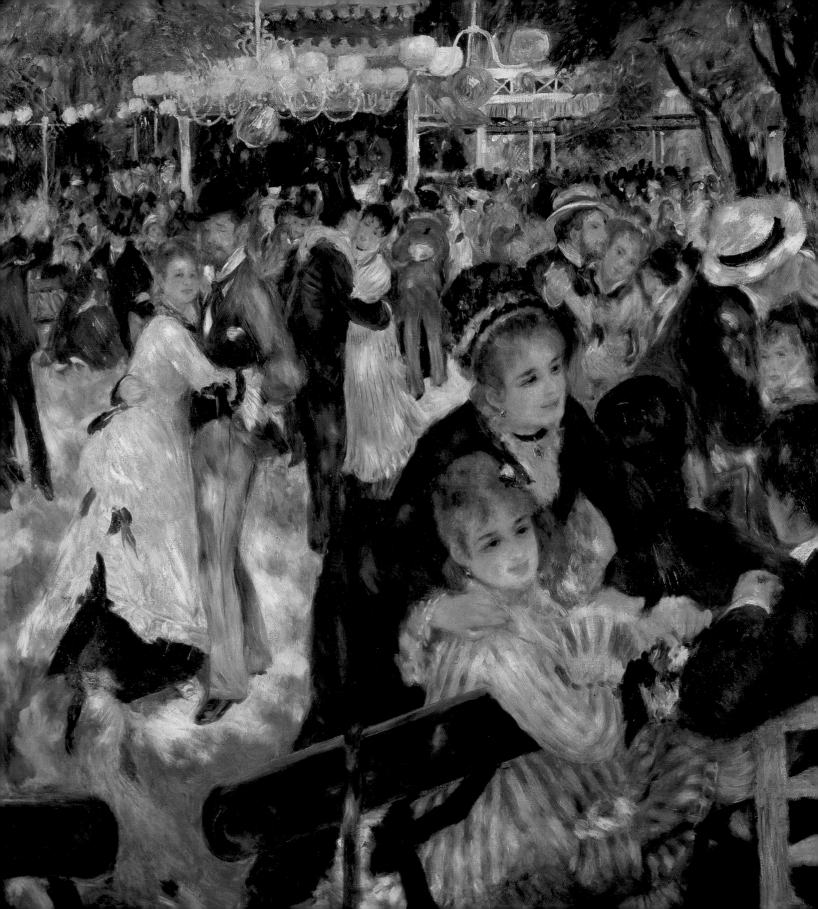

Auguste Renoir

1841–1919

Auguste Renoir
1841–1919

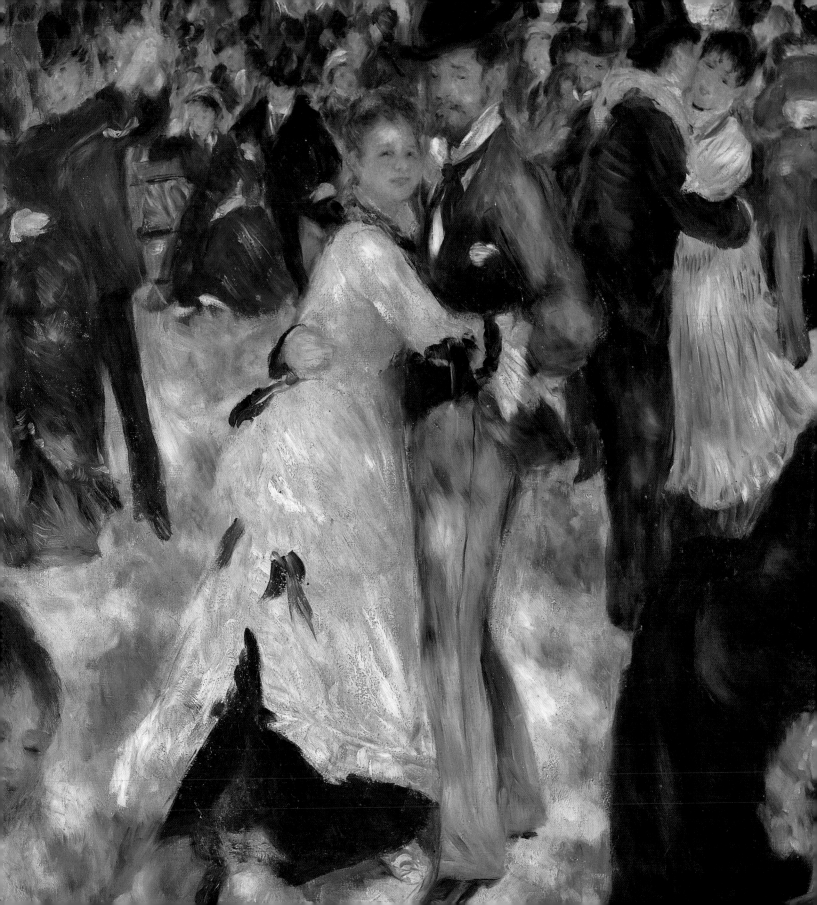

TAKING THE AIR

In the tradition of academic painting, it had been the norm for artists to work in a studio, but with the rise of Impressionism came the new tradition of *plein air,* or outdoor, painting. Monet was a particular advocate of this method, and one of his earliest pieces to use it was WOMEN IN THE GARDEN of 1866–67, which shows a group of women wearing white dresses. White provided him with the perfect base on which to explore the effects of light and reflected color: some of the shadows on the dresses have a green cast, reflected from the foliage, while others show blue-violet, blue as a reflection from the sky, and violet in contrast to the sunlight (violet being the complementary "opposite" to yellow). In the later WOMAN WITH A PARASOL of 1886, a white dress again provided the artist with the same opportunity.

Such was Monet's dedication to *plein air* painting that—if he is to be believed—he produced this mammoth canvas, 8 feet (2.5 meters) tall, entirely out-of-doors. He painted it "on the spot" and from nature, something which wasn't done at the time. He also had, he maintained, to dig a ditch to contain the lower part of the canvas so that he could reach the top to work on it, and was mocked by the painter Courbet for only painting when the sun was shining.

In fact, Monet was stretching the truth here—until around 1914, he painted very few large-scale pieces *en plein air.* WOMEN IN THE GARDEN was certainly begun out-of-doors at Ville d'Avray in 1866, but it was then completed indoors at Honfleur early the following year.

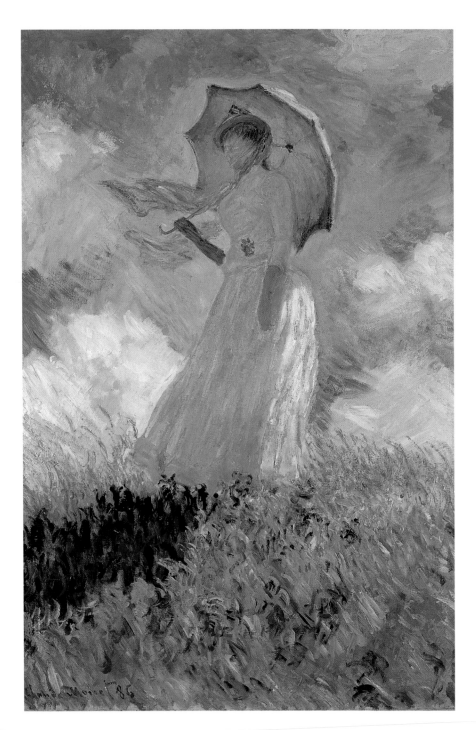

Monet

WOMAN WITH A PARASOL 1886 (above)
WOMEN IN THE GARDEN 1867 (opposite)

35

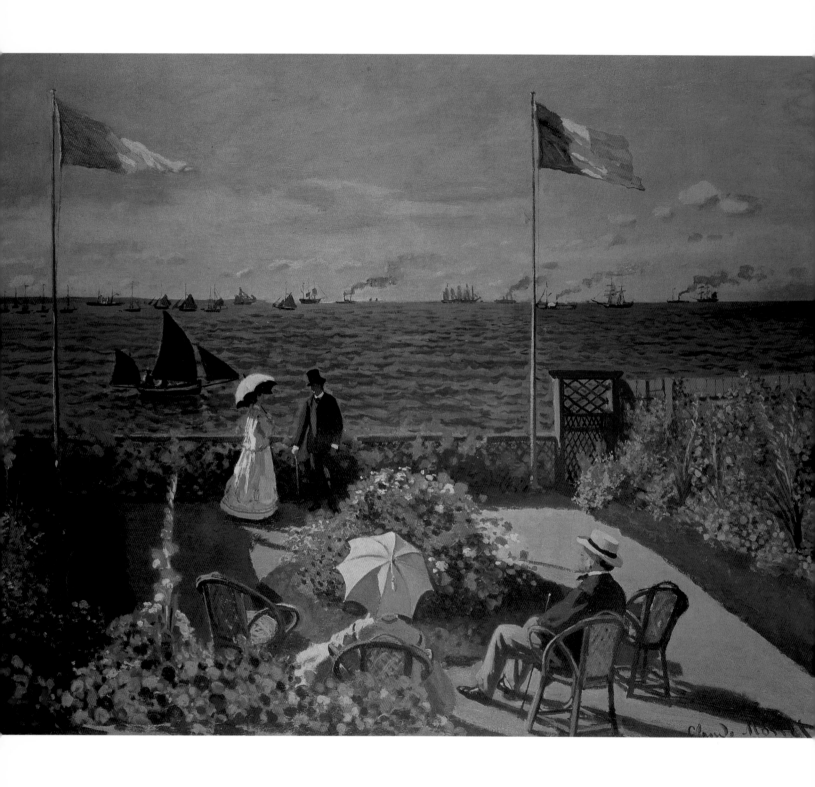

36 A BREATH OF FRESH AIR

BY THE WATERSIDE

The Japanese influence can be detected not only in the composition of many Impressionist paintings, but also in the way in which areas of color have been flattened. One such example is THE TERRACE AT SAINTE-ADRESSE, painted by Monet in 1866 (the artist's father can be seen seated in the right foreground; the two women are thought to be Monet's aunt and niece). For its time, the composition was radical—there is no one single focus of interest, such as a central figure, but several different focal points. In addition, both the sky and the sea have become broadly flattened backdrops, like those of a print, to the terrace and the group of figures scattered across it. The figures are, daringly, turned away from or even with their backs to the viewer.

Monet
THE TERRACE AT SAINTE-ADRESSE 1866

Acknowledging its inspiration, Monet referred to this picture as his "Chinese painting with flags in it," the terms Chinese and Japanese being interchangeable at the time to denote Far Eastern in general. What is notable about this work is its striking similarity, both in composition and subject matter, to THE SAZAIDO OF THE GOHYAKU RAKAN-JI TEMPLE by Hokusai, of which Monet owned a copy, one of the Japanese artist's famous THIRTY-SIX VIEWS OF MOUNT FUJI. Both these compositions feature figures on a terrace by the sea, which is framed on either side by two uprights—flagpoles for Monet, a fencepost and the corner of a building for Hokusai—that lead the eye to the horizon.

NATURE LOVERS

The floral theme that dominated Monet's final years as an artist was anticipated in earlier studies, facilitated by his moves progressively deeper into the countryside. In 1871, with his wife Camille and son Jean, he set up home at Argenteuil on the river Seine just downstream from the city. One of his paintings from this period is WILD POPPIES NEAR ARGENTEUIL, showing an idyllic, poppy-filled meadow through which a small group is taking a stroll. The red dots of the poppies almost form an abstract pattern, reminiscent of the famous waterlilies that he would paint much later.

In 1878, the family, now including two sons, moved to Vétheuil, set in the countryside in a bend of the Seine, 40 miles from Paris. Monet was almost as keen a gardener as he was a painter, and his house at Vétheuil was surrounded by an archetypal country garden, which hinted at the glory he would later create at Giverny. Although his painting of this garden is dated 1880, Monet in fact did three smaller canvases of the same subject in 1881, so the larger work may have been completed later than 1880 from these studies, an hypothesis supported by the fact that the signature on the painting is in the handwriting of Monet's old age.

What is interesting about WILD POPPIES NEAR ARGENTEUIL and THE GARDEN AT VÉTHEUIL is seen in the relationship between nature and the human figure. In both, the figures are almost incidental and nature dominates, indicating an increasing shift in Monet's work toward landscape painting.

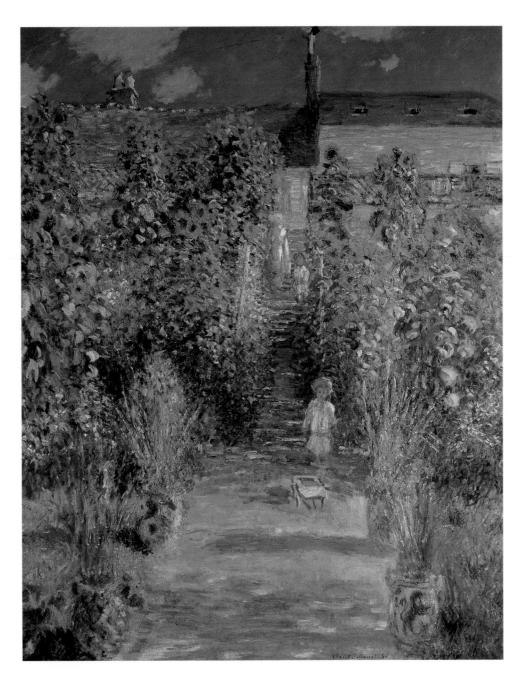

Monet

THE GARDEN AT VÉTHEUIL 1880 (above)
WILD POPPIES NEAR ARGENTEUIL 1873 (opposite)

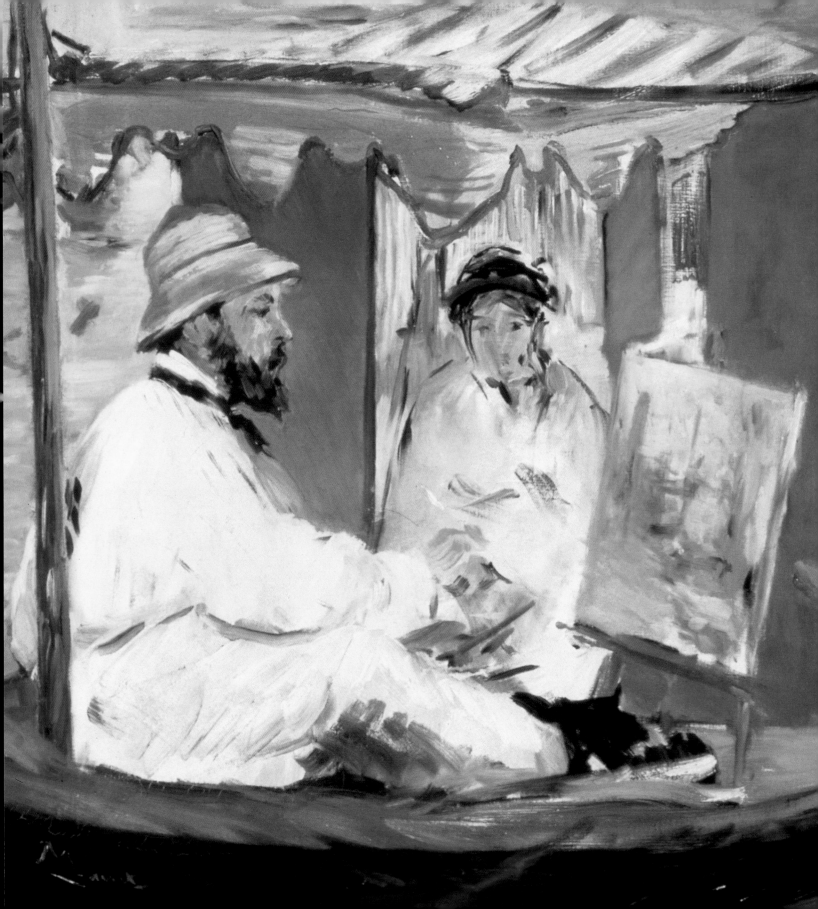

ON THE WATER

In order to facilitate his *plein air* painting, Monet had a boat built that he could use as a floating studio, which was probably funded by a successful sale. The vessel, converted into a studio with the help of Monet's friend and fellow painter Gustave Caillebotte, was launched in 1873. This was not an original idea: Monet's studio boat was almost identical to that of Charles-François Daubigny's, which had been launched back in 1857. However, while Daubigny exploited the full potential of his boat, staying on board to work for days at a time, Monet seems to have moored close to home at Argenteuil and then at Vétheuil, and to have stayed within a short distance of these two sites while working afloat.

Nevertheless, Monet must have found it beneficial to have a floating studio where he could be in the middle of the river, banks, and sky that he was painting, for he maintained the facility into the 1890s, although not with the original boat. Manet captured Monet painting on his boat in 1874, when they worked together at Argenteuil to the north of Paris. Manet's painting shows the considerable influence that Monet had on him. In the same year, Monet painted Manet in his garden at Argenteuil, while the previous year Renoir had painted Monet working there.

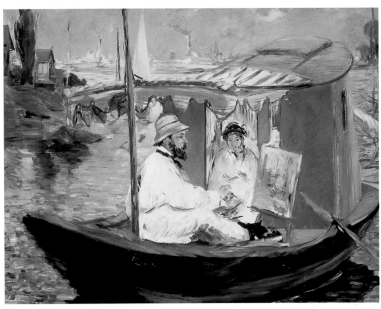

Manet
MONET IN HIS FLOATING STUDIO 1874
(above and detail opposite)

OPEN-AIR CONCERTS

Impressionist paintings sometimes read like a who's who of the artistic and literary worlds of Paris in the second half of the 19th century. Answering the poet Charles Baudelaire's call to artists to depict modern-life subjects—Baudelaire called for a painter to show "how great and poetic we are in our frock-coats and patent leather boots"—Manet did just that, and put the poet himself in one of his paintings. An admirer of some of the Old Masters, Manet took a painting then wrongly attributed to Velazquez, which purportedly showed the artist and a group of his friends, and translated the theme into a contemporary scene. The result was MUSIC IN THE TUILERIES GARDEN (MUSIQUE AUX TUILERIES), of 1862, showing Manet and some of his friends enjoying an open-air concert in a park in Paris. As well as Baudelaire, there is the poet and novelist Théophile Gautier, the composer Jacques Offenbach, the artist Fantin Latour, the critic Jules Champfleury, and Manet's brother Eugène; Manet is on the far left.

The work was done in the studio, although Manet is said to have worked outdoors in the afternoons, between 2 and 4 o'clock, making studies for it during 1861. Velazquez may have provided the impetus for the piece, but in other ways it was thoroughly modern. The frieze-like disposition of the figures giving a more-or-less even focus across the canvas was novel, and caused critics to accuse it of having no composition, while the lack of much preparatory underpainting and the use of pure black were a break with academic techniques.

Manet
MUSIC IN THE TUILERIES GARDEN 1862

43

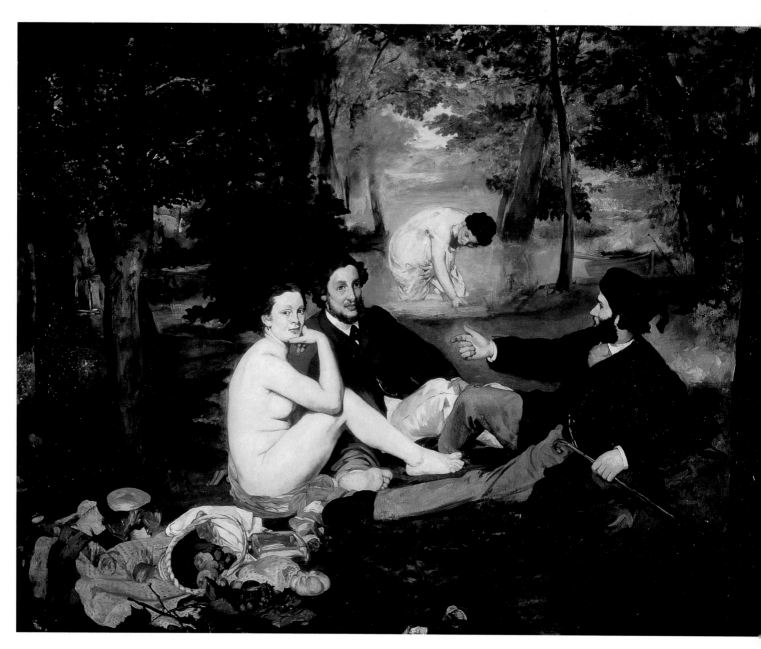

Manet
LUNCHEON ON THE GRASS 1863 (above)
BOATING 1874 (opposite)

GOING PICNICKING

If the Impressionists had deliberately set out to shock the public, they could not have achieved their aim more successfully than Manet with his LUNCHEON ON THE GRASS (LE DEJEUNER SUR L'HERBE) of 1863, which showed a group picnicking in the Forest of Fontainebleau. Having been rejected by the jury of the official Salon, the work was subsequently shown at the Salon des Refusés of 1863, where it caused an uproar. It was not so much the subject matter that offended: the rustic pleasures of the *fête champêtre,* the picnic, had been shown by artists before—indeed, Manet's picture had taken its inspiration from none other than Giorgione, one of the Italian masters, whose CONCERT CHAMPÊTRE of c.1510 hung in the Louvre, while the grouping of its figures had indirectly been based on those in a composition by Raphael. Even the naked woman, as such, was not offensive, for there was a long tradition of the female nude in art.

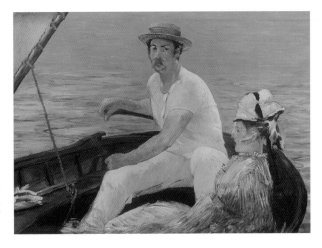

What offended public taste was the painting's "modernity." What Manet had dared to do was to take a traditionally acceptable subject and turn it on its head by giving it a contemporary date. This group of picnickers were no distant historical or mythological figures who did not compromise the viewer, but real, contemporary men and women; worse still, one of the women was shown naked between two fully clothed men. To compound the outrage, she locks onto the viewer's gaze, forcing the viewer to acknowledge her as a real-life, individual, flesh-and-blood woman.

IN THE GARDEN

When it came to painting out-of-doors, Morisot and Cassatt, the two women Impressionists, did not completely succumb to nature as, for example, Monet did, but continued to focus on the same restricted subject matter that they would have painted indoors, namely, women and children. Their subjects may be shown surrounded by grass, trees, and flowers, but the pictures remain resolutely figure paintings and not landscapes.

One such work is Morisot's WOMAN AND CHILD IN THE GARDEN AT BOUGIVAL (FEMME ET ENFANT DANS

LE JARDIN À BOUGIVAL), from 1882. Morisot had a house at Bougival, west of Paris, where she went to paint from nature during the summer months. The picture probably shows her four-year-old daughter Julie with her maid Paisie. Quick, vigorous flecks of color build up the whole in a style that is typically Morisot. What is not typical of the Impressionists, however, is that the canvas was unprimed—this was not a common practice for the Impressionists, since "raw" canvas would absorb the paint, making the colors dull. Later examination revealed that it had in fact been primed, but on the reverse. Morisot had done a painting on the primed surface but, dissatisfied with it, had simply turned the canvas over, tacked it to a new frame and painted this picture on the unprimed side.

Morisot WOMAN AND CHILD IN THE
GARDEN AT BOUGIVAL 1882 (above);
IN A PARK 1874 (opposite)

A BREATH OF FRESH AIR 47

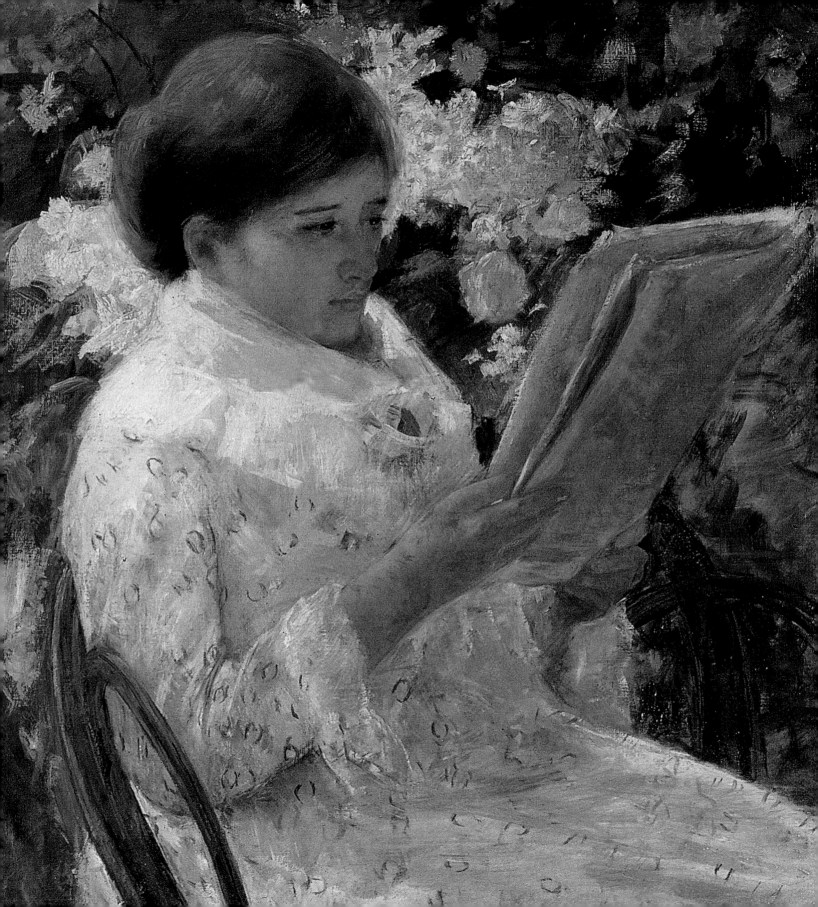

Mary Cassatt

1844–1926

Mary Cassatt

1844–1926

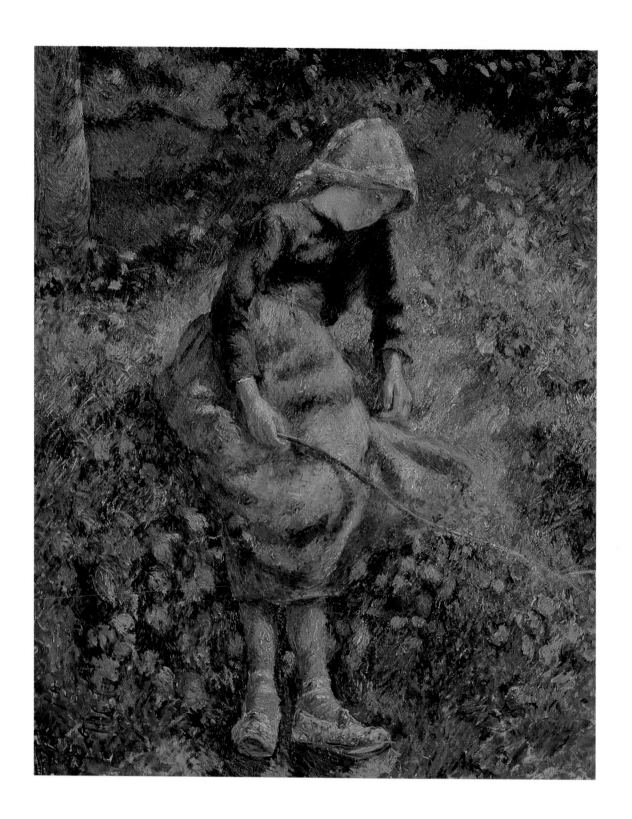

RURAL IDYLL

After years of pursuing similar goals, many of the Impressionists reached a point where they seemed to have exhausted their common artistic purpose. For Renoir, for example, the crisis of confidence occurred around 1883, when he declared that he had reached a dead end, and even questioned his ability to paint and draw. For Pissarro, the period of self-doubt began in the late 1870s. In 1880, however, he worked with Degas on a series of prints for a journal to be called *Day and Night (Le Jour et la Nuit)*. This collaboration with Degas—who was the ultimate urbanite and not remotely interested in nature—and the lack of *plein air* landscape material during the project gave Pissarro a new focus: he turned to figure painting.

Of course, Pissarro did not go as far as Degas and look for inspiration among the demimonde of the city. With his lifelong anarchist tendency and automatic detestation of the bourgeoisie, Pissarro's natural subjects were the peasants of rural France, perhaps picking apples in the orchard or resting on a bank while tending the sheep, as in YOUNG GIRL WITH A STICK (JEUNE FILLE ET LA BAGUETTE) of 1881. However, although these subjects may have accorded with some of Pissarro's egalitarian views, and although he was an artist interested in visual effects and not social history, he does present us with a somewhat idealized vision of rural life and peasant toil.

Pissarro

YOUNG GIRL WITH A STICK 1881 (opposite)

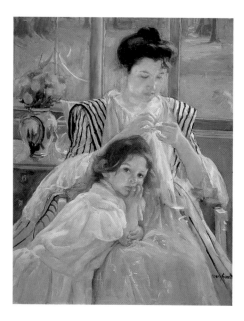

Cassatt
YOUNG MOTHER SEWING c.1890

BY THE WINDOW

The Impressionists were fascinated by the effects of natural light on color, whether indoors or outdoors. One painting that exemplifies this is IN THE DINING ROOM by Berthe Morisot. As was so often the case with Impressionism, the subject matter could not be more ordinary—the picture shows the artist's maid caught in mid-movement in a room in her house in the Rue de Villejuste, Paris. Behind her light floods into the room through huge windows, so that she is seen *contre-jour* (against the light).

What clearly caught Morisot's eye in this domestic scene was not the figure itself, but the opportunity it afforded to explore the interplay of light and shade. Although the composition is conventional—the figure is placed centrally to give it precedence—the treatment of light and shadow breaks with tradition. Formerly, it had been the custom to render shadow with dark, transparent hues and lighter areas with opaque color, and to accentuate the contrast between lights and darks. Morisot, along with the other Impressionists, rejected this approach. Instead, she evened out tonal contrasts and applied brushstrokes of solid color to convey shadows glowing with reflected light. This technique is most effectively demonstrated in the maid's apron, and in the shadow she casts on the shiny wooden floor—all are rendered with quick, lively brushwork to convey the dissolving effect of light on form.

A similar challenge was explored by Mary Cassatt in her YOUNG MOTHER SEWING, which also shows figures *contre-jour,* in front of a window.

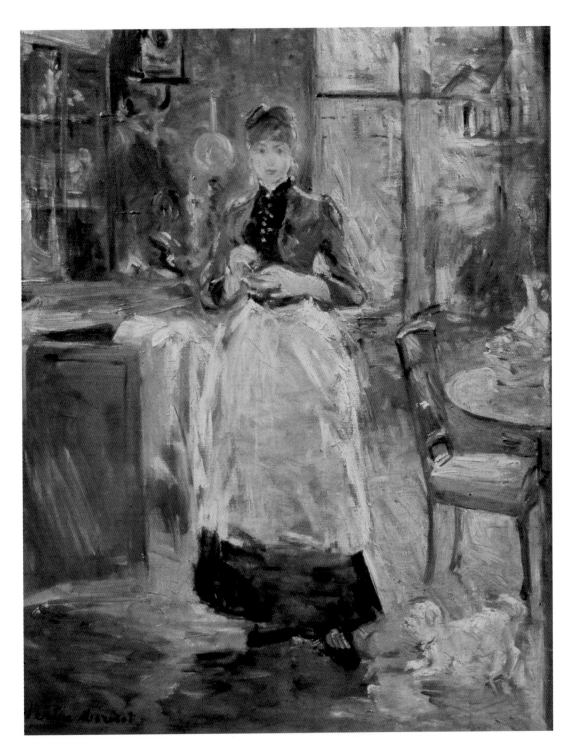

Morisot IN THE DINING ROOM 1886

TOWNSCAPES

Monet

SANTA MARIA DELLA SALUTE AND THE GRAND CANAL, VENICE 1908

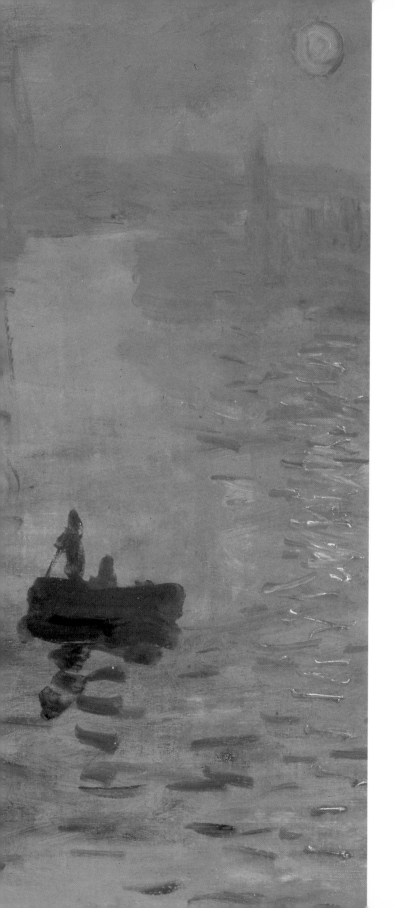

IMPRESSIONS ON VIEW

When, in 1874, the artists who later came to be known as Impressionists decided to hold their first group show, Edmond Renoir, brother to the painter, was given the task of editing the catalog for the show. While having difficulty with the monotonous titles that Monet had given his paintings, he arrived at one showing a sunrise over Le Havre harbor, dated 1872, for which the artist came up with the solution: "Call it Impression," he said. The painting was accordingly entered as IMPRESSION: SUNRISE. When one of the critics, Louis Leroy, saw the painting, he thought the title as well as the idea behind it, that an "impression" was enough to make a painting, laughable, and clearly said so in the humorous journal *Le Charivari*, where he dubbed the new school "Impressionism." The name stuck and this group of painters have been known as Impressionists ever since.

Monet later declared his distress at having been the source of this name. In a letter written shortly before his death, he said that he had always hated theories of art, that all he had ever tried to do was to convey his personal impressions of fugitive effects, and that the majority of artists who were grouped under the heading "Impressionist" were nothing of the sort.

For a long time, there was confusion as to exactly which painting gave rise to the term Impressionism. It was originally believed to be the picture now known as IMPRESSION: SETTING SUN, also painted in 1872. However, this was not exhibited until the fourth Impressionist exhibition, held in 1879, so the definitive picture must have been IMPRESSION: SUNRISE, exhibited five years earlier.

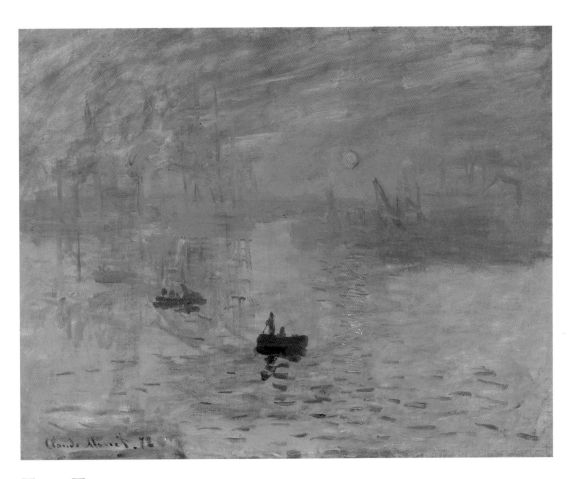

Monet
IMPRESSION: SUNRISE 1872 (above and detail opposite)

TOWNSCAPES 57

STREET SCENES

The location chosen for the first Impressionist group exhibition, from April 15 to May 15, 1874, was the vacated studio of a photographer, Nadar, situated at 35 Boulevard des Capucines. If you had happened to be there, the scene you might have glimpsed from one of the windows could have looked exactly like that in Monet's BOULEVARD DES CAPUCINES of 1873. In fact, the actual viewpoint from which the artist painted this picture was the balcony of Nadar's studio.

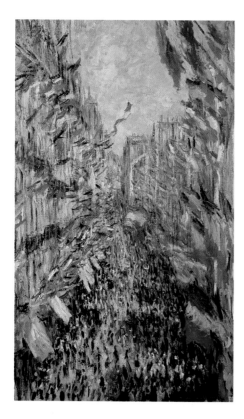

Shown as part of the 1874 exhibition, BOULEVARD DES CAPUCINES came in for the same ridicule from the critic Louis Leroy as the painting IMPRESSION: SUNRISE received. Leroy derisively described Monet's method of painting the crowd as "black tongue-lickings." What viewers seeing Impressionist paintings for the first time failed to realize was that it was necessary to stand a good distance away from the canvas in order for the colors and shapes to take meaning and form and come to vibrant life.

Five years later, Monet used the same technique, taken to even greater extremes, in another historically significant Parisian street scene, when he painted THE FÊTE NATIONALE IN THE RUE MONTORGEUIL in 1878. The picture was painted from a balcony in Les Halles, the well-known Paris market, and showed the crowds optimistically celebrating the first national holiday, on June 30, 1878, since the ending of the war with Prussia and the Paris Commune. This would be one of Monet's very last paintings of Paris.

58 TOWNSCAPES

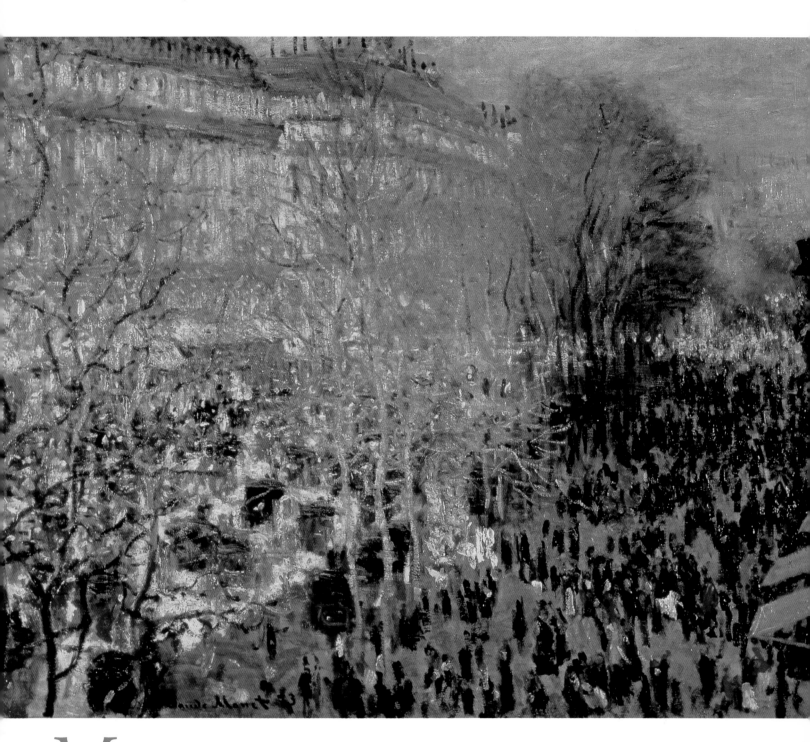

Monet

BOULEVARD DES CAPUCINES 1873 (above)
THE FÊTE NATIONAL IN THE RUE MONTORGEUIL 1878 (opposite)

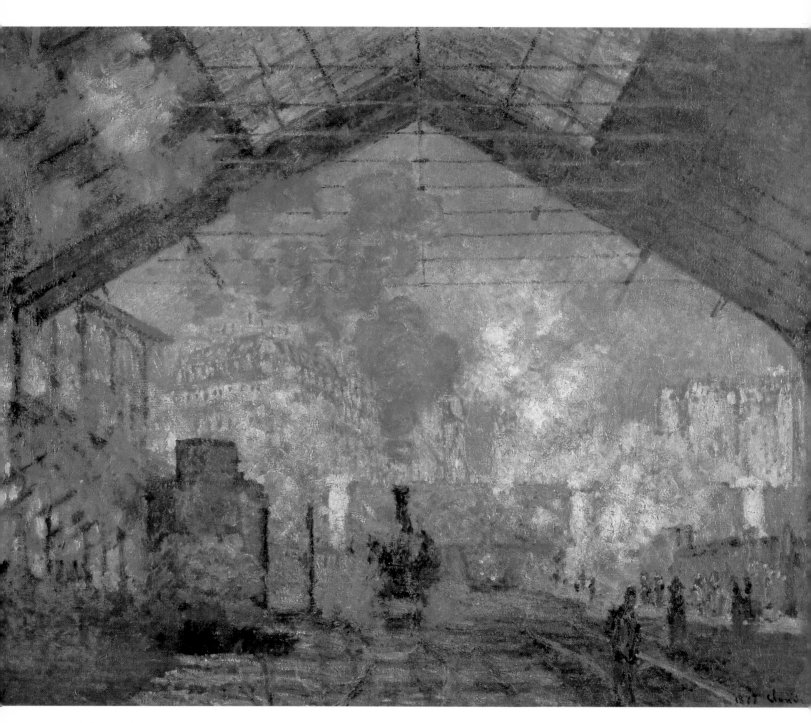

Monet ST. LAZARE STATION 1877 (above)
TRAIN IN THE SNOW 1875 (opposite)

RAILWAYS

The Gare St. Lazare in Paris was the railway station that served northeastern France and the Channel ports, and Monet would have been familiar with it from his trips to Normandy and England. With its arrivals and departures, its general hum of activity, and its huge glass-roofed enclosure opening onto the world outside and framing distant buildings and sky, it proved irresistible to Monet. Here, during 1877, he set up his easel in different parts of the station so that he could explore the same subject from different angles.

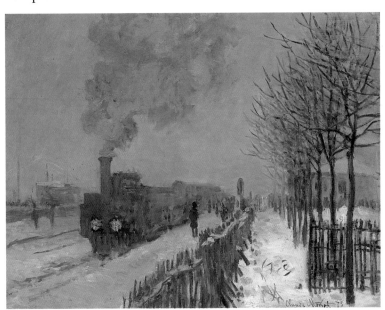

The subject had been anticipated in an earlier painting of 1875, TRAIN IN THE SNOW, but the ST. LAZARE STATION paintings offer a thoroughly urban scene. Although the railway was a powerful symbol of 19th century industrialization, Monet was not attempting to make any social comment in choosing to depict such material, unlike his friend, the writer Emile Zola, who saw a kind of nobility in rail. What attracted Monet, as an artist, were the pictorial aspects of the scene—light filtering through the glass roof, steam locomotives puffing clouds of smoke, and all bound together visually by the hazy atmosphere within the station enclosure. And, according to Renoir, Monet decided to paint the smoke-filled station after critics of some of his earlier work commented that fog was not a suitable subject for a painting.

TOWNSCAPES

ARCHITECTURAL SPLENDOR

One of the features of Monet's later years as an artist was his liking for painting series of the same subject. Having the leisure to explore and experiment in this way was certainly helped by his newfound prosperity, and one of the subjects he chose to put under scrutiny was Rouen Cathedral.

From 1892–94, Monet produced a series of canvases—about twenty in all—showing the great cathedral in a sequence of views that ran from morning to sunset. His aim, he said, was to convey architecture "without lines or contours," and to this end he avoided sharp contours and accents, building up the surface with thick, almost encrusted layers of color. Some have likened this texture to that of stonework, as if Monet were attempting to convey the solidity of stone itself, but certain parts of the sky have also been given the same treatment. The effect of Monet's technique is that the eye is distracted from architectural detail, as the building appears to blend and melt into the atmosphere cloaking it— Monet's "envelope." As usual, Monet was striving for the overall impression, and the sense of light and time of day in these paintings is almost palpable.

Although Monet's series met with great success, it was not without detractors. Some of his former colleagues felt that he was too interested in technique for its own sake, while Degas had always maintained that Monet was merely a very skilled decorator.

Monet
ROUEN CATHEDRAL 1892–94 (both)

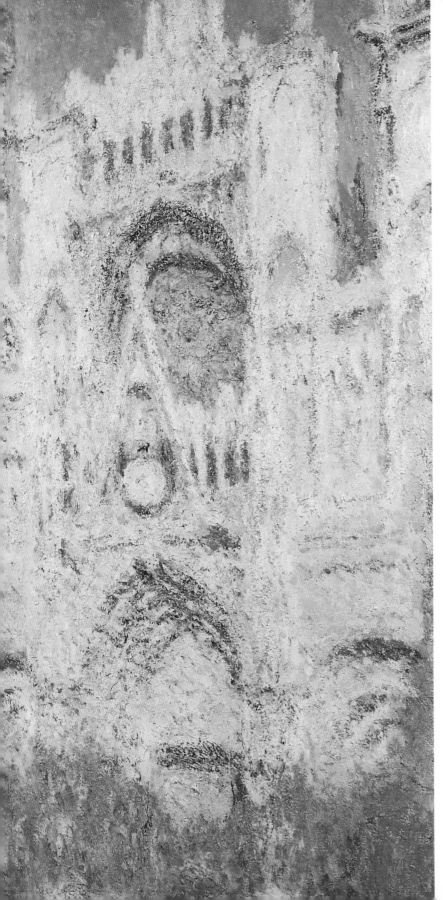

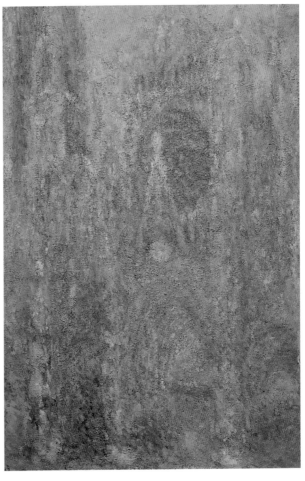

63

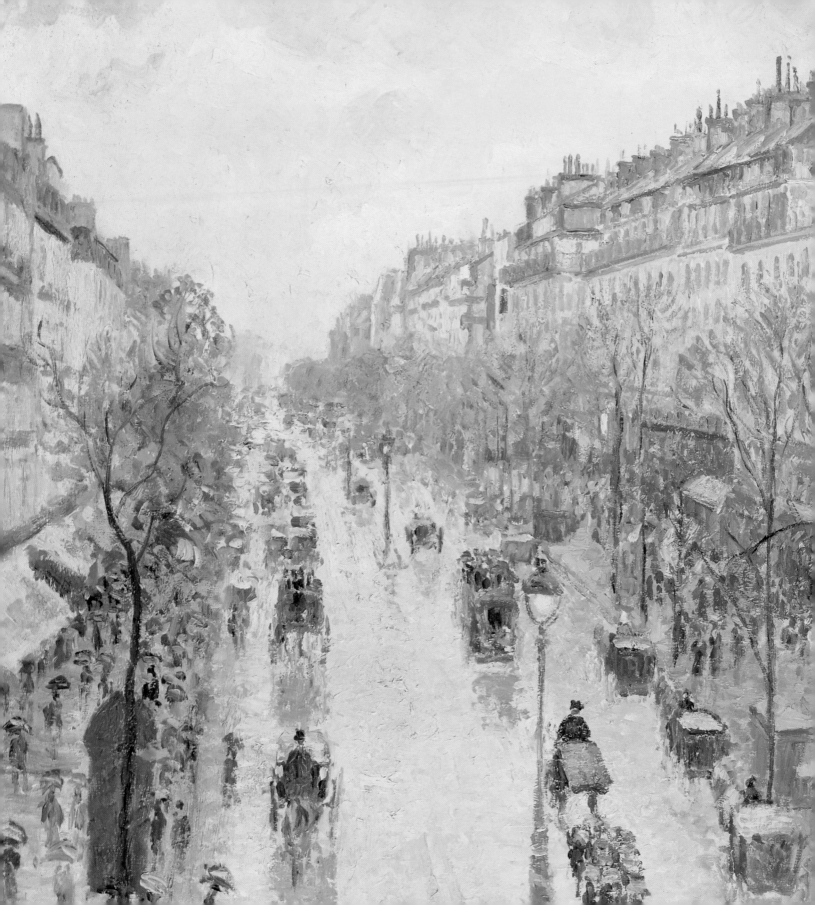

Camille Pissarro
1830–1903

Camille Pissarro
1830–1903

FOREIGN PORTS

In addition to his pictures of Parisian scenes, Monet's work also includes paintings of other cities. He had already visited London in 1870, when he fled there to escape war in France. Later, in more peaceful times around the turn of the century, another visit to London yielded a number of paintings of bridges over the Thames and famous riverside landmarks such as the Houses of Parliament.

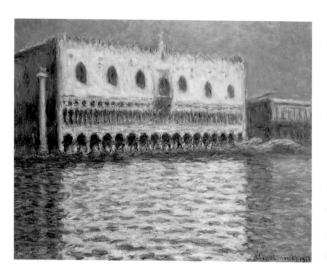

One of the more popular subjects in his London series of 1899–1901 was Charing Cross Bridge, which Monet painted more than once. Since the importance of all his series paintings was that they be seen as a whole, it was vital to achieve some unity across them, and this sometimes involved a little cheating. For example, from his chosen viewpoint of Charing Cross Bridge, the obelisk known as Cleopatra's Needle would have been visible, affecting the composition and altering the unity of color and atmosphere that the painter sought to convey—so he simply omitted it when it suited him.

Working so far from home meant that Monet sometimes had to finish his paintings in the studio. In this respect, London, which had a climate and a quality of light with which he was familiar, was not so much of a problem as Venice, which Monet visited late in 1908. The "atmosphere" here was not one he knew, and he felt he never mastered it. He returned from the city with a number of paintings still to be completed in the studio during the winter, and was thus forced to work from memory, not nature, and he felt it showed. In his Venice paintings, nature, he said, had "had her revenge."

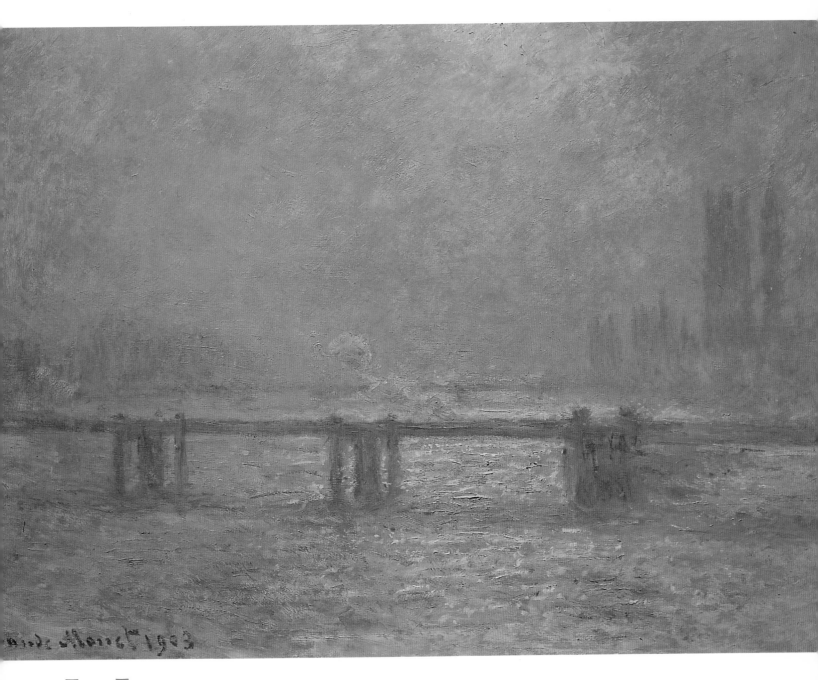

Monet
CHARING CROSS BRIDGE, THE THAMES 1899–1901 (above)
THE DOGE'S PALACE, VENICE 1908 (opposite)

BY THE RIVER

Argenteuil, on the banks of the Seine on the outskirts of Paris, is probably more strongly associated with the Impressionists than any other place, for at one time or another almost every one of the core group came here to paint. The tranquil scenes they depicted are a little deceptive, for in the early 1870s Argenteuil was an industrialized suburb of Paris, with a population of around 8,000 people. It did, however, have the broad river, with sailing boats and bridges, and it was this that attracted the artists.

Monet had already taken up residence at Argenteuil in late 1871, and was joined by Sisley the following year, the two artists setting up their easels side by side to paint the same street scene. Unlike some of the other Impressionists—including Monet, who continued to explore new styles of art—Sisley remained remarkably consistent, preferring to paint as he had always done rather than experimenting with new techniques. However, in his later years, Sisley began to include brighter colors in his palette, in addition to the somber browns, greens, and grays that feature in his early work.

In spite of a lack of financial support after the death of his father and in spite of his timid nature, Sisley seems in the early 1870s to have begun to paint with newfound confidence and skill. Among a number of paintings of Argenteuil dating from this period is one showing the footbridge across the Seine. In this composition—daring for its time—one again detects the Japanese influence, for the footbridge itself is set off-center and the lack of a single focal point spreads the visual interest across the picture space.

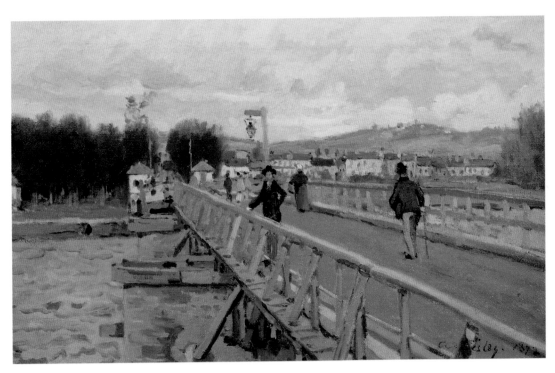

Sisley BRIDGE AT ARGENTEUIL 1872
(above and detail opposite)

Sisley

FLOODS AT PORT-MARLY 1876 (below and detail opposite)

FLOATING ON WATER

Lying to the west of Paris, the villages of Marly-le-Roi, Port-Marly, Celle St. Cloud, and Louveciennes and their environs provided Sisley with a rich store of subject matter during the 1870s. In 1876, a flood at Port-Marly resulted in a series of paintings that form some

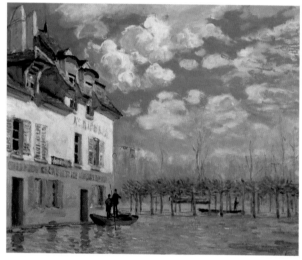

of Sisley's best work. The flood totally transformed the appearance of the village, making buildings and trees appear to float on the water, and allowing the artist in Sisley to explore their reflections in the gently ruffled surface against the backdrop of a wide sky.

Like Monet, Sisley always liked the subtle atmosphere and nuances of color created by overcast skies, and remained true to Impressionist ideals to the last. However, unlike the more commercially minded Monet, Sisley was of a retiring nature and after 1880 lived in relative isolation, which may account for the lack of acclaim during his lifetime. Although his work had always been appreciated by a small group of discerning collectors, it was only after his death that he received the recognition he deserved. In 1900, only one year after he died, one of his paintings of the Port-Marly flood, which Sisley himself had originally parted with for 180 francs, sold for a staggering 43,000 francs.

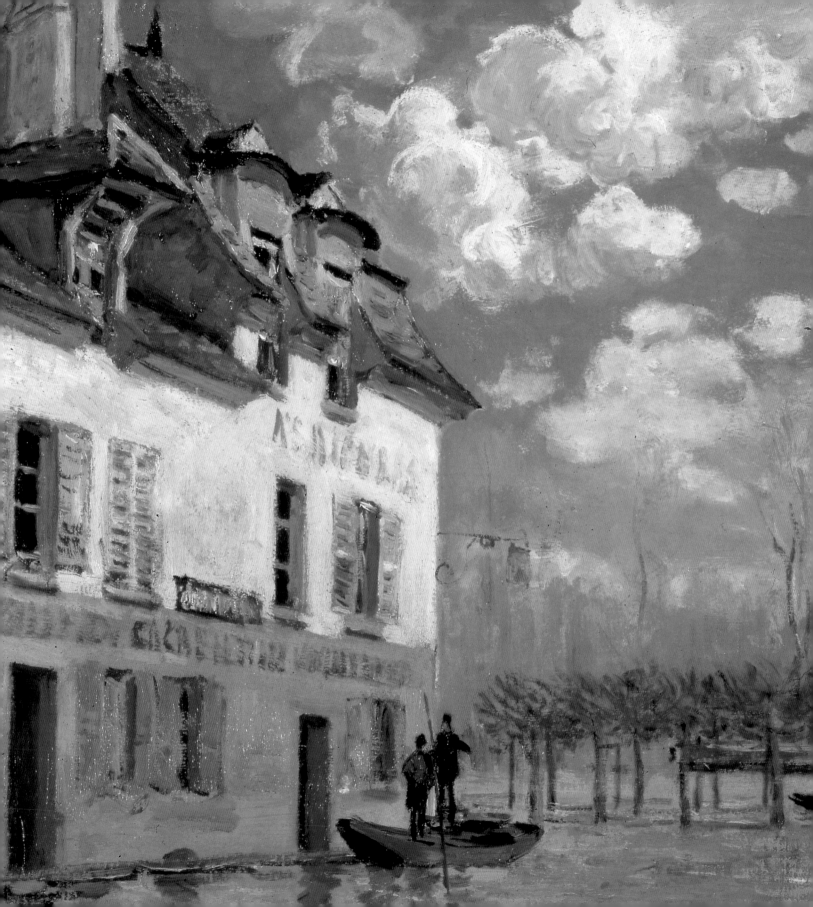

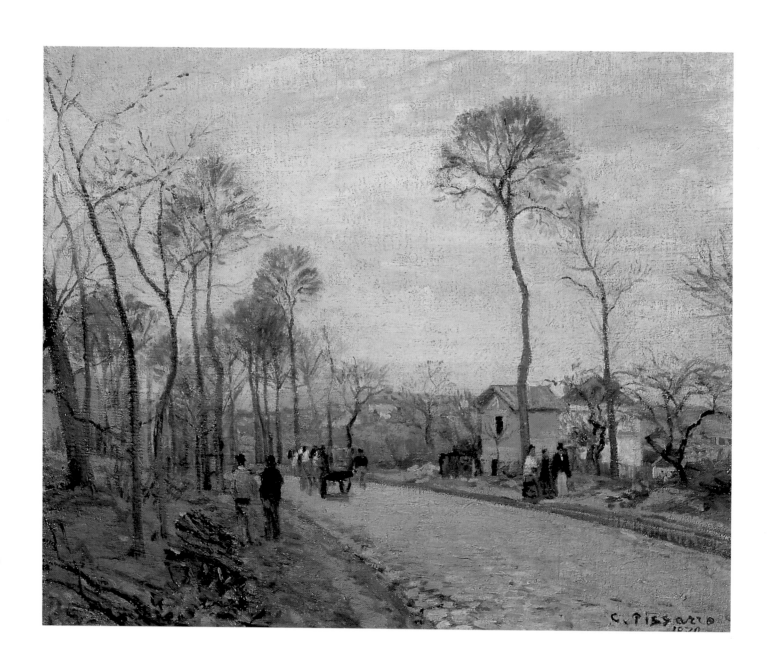

72 TOWNSCAPES

ON THE ROAD

Louveciennes, a village west of Paris, had been Pissarro's home before the outbreak of war between France and Prussia, and it was to Louveciennes that he returned after the war and his self-imposed exile in London. He painted a number of pictures of the village, in sun, snow, and rain.

If one looks carefully at the Louveciennes paintings and others in Pissarro's body of work, an interesting feature quickly becomes apparent: Pissarro liked to paint pictures of roads. Of course, he was not literally attracted to the road itself, but to the compositional possibilities it offered. In the Louveciennes series of paintings, the composition remains remarkably similar. The road through the village provides the backbone to the arrangement. Broad in the foreground, the road quickly narrows toward a vanishing point in the distance. Almost invariably seen from a fairly low viewpoint, and from slightly to one side, its strong linear form cuts diagonally across the picture plane. Almost invariably, too, pairs or small groups of figures are dotted along its course, while the strong verticals of buildings and trees offer a contrast to the flatness of the foreground and the wide sky.

The geometry that underpins Pissarro's work, with its intersecting forms, can be seen in other, later works such as THE CÔTE DES BEOUFS AT THE HERMITAGE, PONTOISE of 1877.

Pissarro
THE ROAD, LOUVECIENNES 1870 (opposite)

A ROOM WITH A VIEW

In his later years, Pissarro was affected by a chronic eye infection, which increasingly prevented him from working out-of-doors. He moved indoors, and, determined to continue painting the subjects that interested him, painted what he could see from the window. In 1884, he moved to Eragny-sur-Epte, to the north of Paris, and when he had exhausted the views from his studio there, he began to travel—to London, Rouen, and Paris—and set up his easel by a window wherever he could get a good view of the scene outside.

Where once Pissarro had concentrated on rural landscapes, he now produced a series of marvelous townscapes, in what is arguably the best work he ever did. In Paris, he painted day and nighttime scenes of the Boulevard Montmartre. By day, it was a bustle of crowds and horse-drawn trams; by night it was transformed into a glittering vista of street lights and carriage lamps, which evoked all the glamor that was *fin-de-siècle* Paris. Pissarro wrote: "I am enchanted with the idea of painting the streets of Paris which people call ugly but which are so silvery, so luminous and so lively …It is the modern idiom in full."

Only six years away from his own death, Pissarro had by now returned from his forays into Pointillism to his original Impressionist ideas—as he wrote to his son, Lucien, in 1889: "The manner of execution is not swift enough for me and does not respond simultaneously with the feelings within me." The painting of THE BOULEVARD MONTMARTRE AT NIGHT, dated 1897, also recalls another favorite old theme, for it is one more of Pissarro's "road" paintings, like those of Louveciennes created over 25 years earlier.

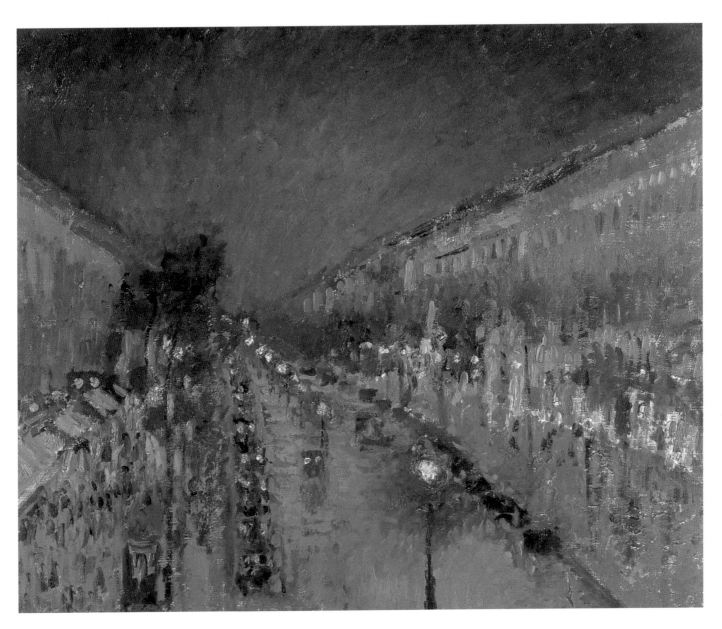

Pissarro

THE BOULEVARD MONTMARTRE AT NIGHT 1897 (above and detail opposite)

TOWNSCAPES 75

Monet

REGATTA AT ARGENTEUIL c.1872

GLORIES OF

NATURE

WINTER LANDSCAPES

Even the harshest weather conditions were not enough to keep Monet from his art. His reputation as a dedicated *plein air* painter was reinforced by a journalist who, writing in 1868, described the artist working outdoors at Honfleur, in deep snow in conditions cold enough to "split stones." In the white winter landscape, the first thing the journalist noticed was a footwarmer, then an easel, then a man wrapped up in three coats and wearing gloves. It was, of course, "Monsieur Monet," studying a snow effect, oblivious to all else.

With his keen eye, what Monet saw in the "white" of the snow was a rainbow palette of delicate colors. THE MAGPIE of 1869 is a particularly good example.

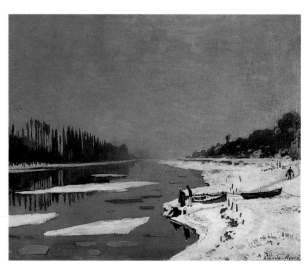

There is very little pure white in the painting. The shadows of the hedge, gate, trees, and rooftop—seen *contre-jour* against the silvery sky—are built up of iridescent blues, pinks, beiges, and mauves, perfectly demonstrating how the reflective snow surface bounces light back into the shadows, causing them to glow.

Occasions when the river Seine froze provided Monet with another chance to explore the subtle hues and luminous light quality of the winter landscape. One such work is ICE-FLOES ON THE SEINE AT BOUGIVAL, painted 1867–68. When the river again iced over and then thawed in January 1880, Monet returned to this subject, this time producing a series of paintings of it.

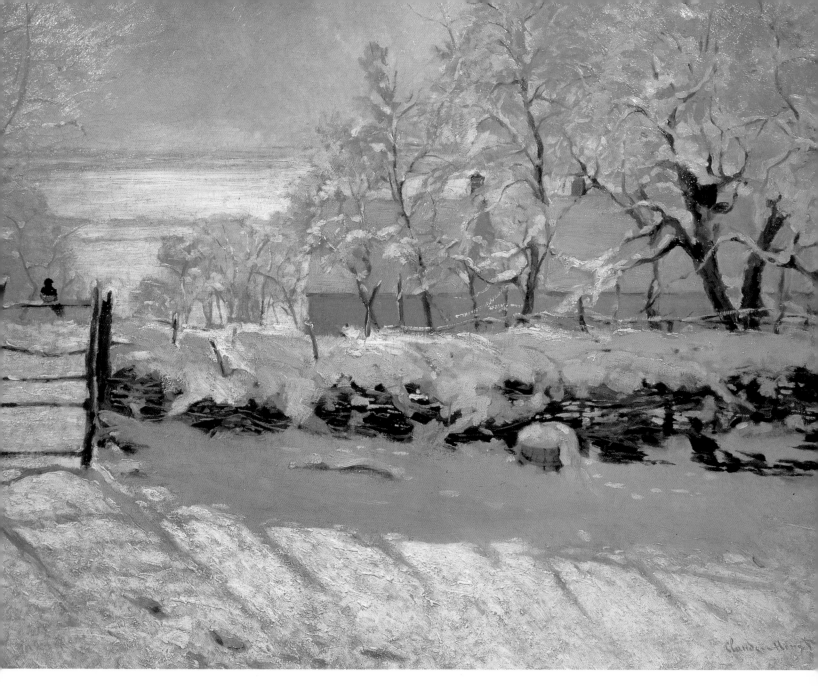

Monet

THE MAGPIE 1869 (above)
ICE-FLOES ON THE SEINE AT BOUGIVAL 1867–68 (opposite)

GLORIES OF NATURE 79

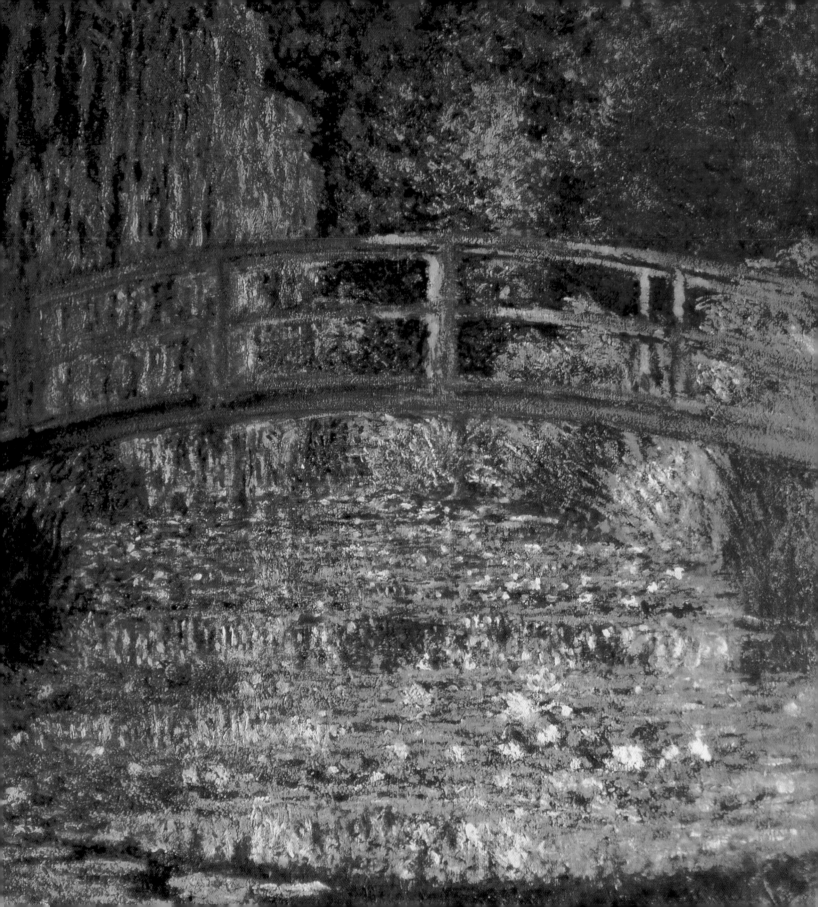

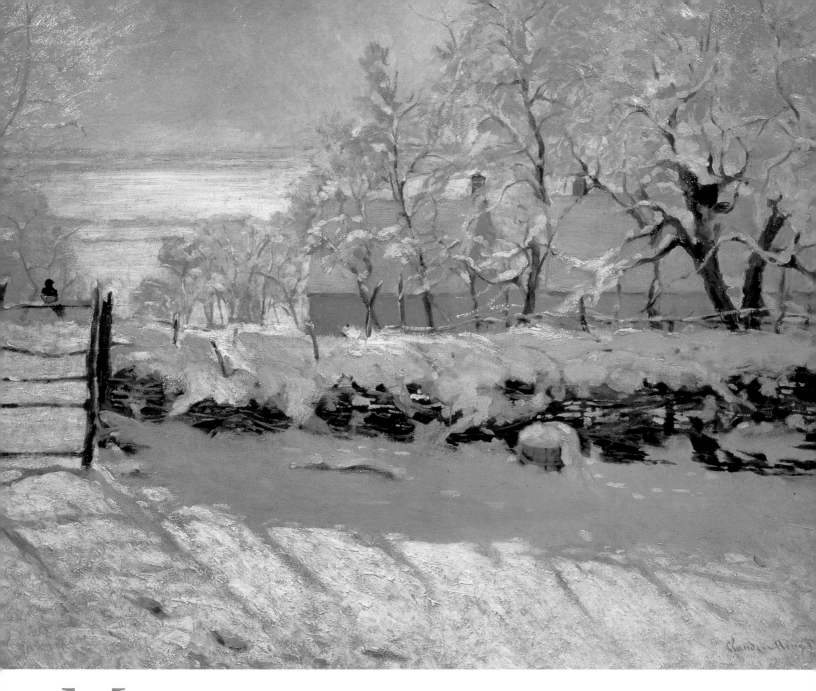

Monet
THE MAGPIE 1869 (above)
ICE-FLOES ON THE SEINE AT BOUGIVAL 1867–68 (opposite)

GLORIES OF NATURE 79

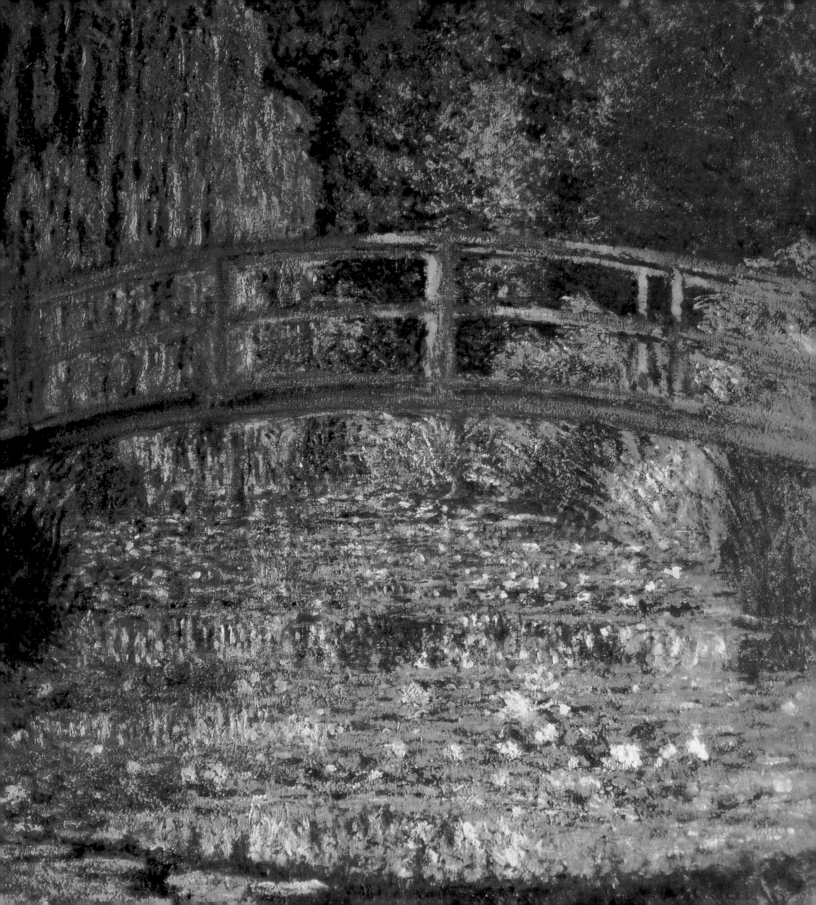

Claude Monet
1840–1926

Claude Monet

1840–1926

A WORLD APART

In 1883 Monet rented a house with a large garden in the village of Giverny. Here, Monet was able to indulge in what he claimed were his two greatest passions—painting in the open air and gardening—and all on his own doorstep. Monet transformed the garden with a tumbling profusion of flowers into one of the most famous gardens in the world and a destination for art lovers everywhere. It would be a source of solace and inspiration to him for the rest of his days.

In 1890, as Monet was gradually becoming more established as an artist, he was able to borrow enough money to buy the house at Giverny. Like the other Impressionists, his paintings had always been much influenced by the work of Japanese printmakers, and now he intended to extend that influence to his surroundings and build a Japanese water garden. By July 1893, he had obtained permission to build a pond, and by October the little green bridge—one of two he would build—was in place. It can be seen spanning the pond in THE WATERLILY POND of 1899.

Monet's plans did not stop there, however. In 1901, a purchase of further land enabled him vastly to extend the pond. Artistically, the result was equally grand, for it was after this that Monet began his famous and monumental series of waterlily paintings.

The garden at Giverny became Monet's whole world. His working day began there at five in the morning, when he would wander around his beloved garden before setting up his canvas. Later, in 1914, when cataracts in both eyes made it impossible for him to work outdoors, he had a studio built in the garden and painted there instead.

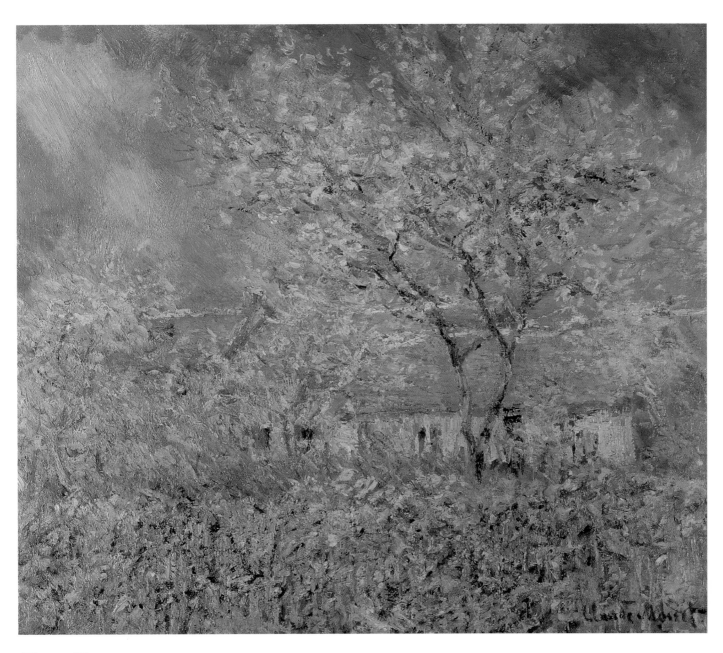

Monet
SPRINGTIME AT GIVERNY c.1905 (above)
THE GARDEN AT GIVERNY c.1900 (opposite)

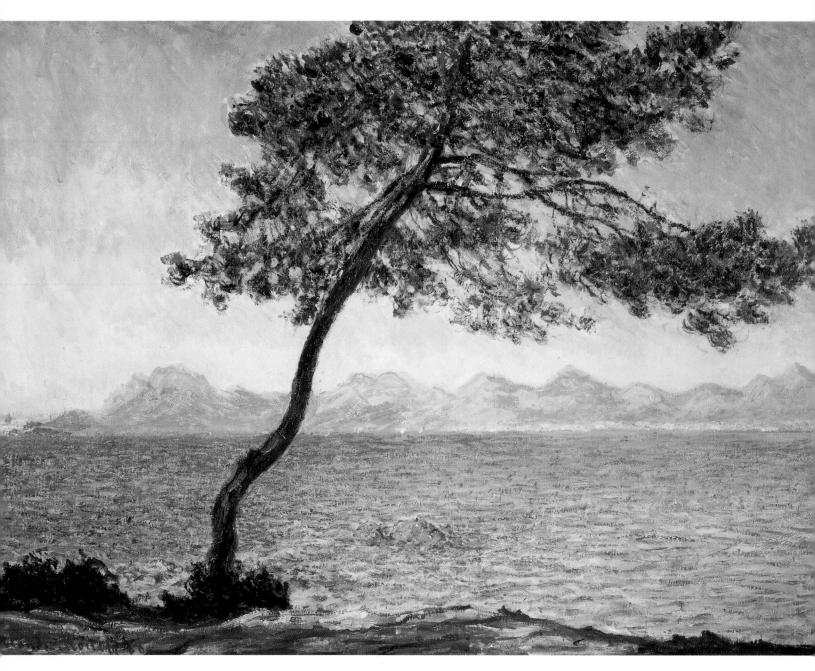

Monet

ANTIBES 1888 (above)

THE SEA AT FÉCAMP 1881 (opposite)

AT THE SEASIDE

In his youth, Monet had painted on the coast of northern France and the sea, in all its moods, remained fascinating to him. From 1881, he returned regularly to his old haunts on the northern coast, where he would paint furiously. As the writer Guy de Maupassant, who often watched Monet at work during 1885, observed,

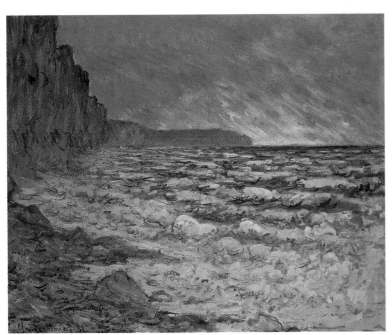

these were literally his "hunting grounds." Monet, de Maupassant said, was no longer a painter but a hunter who "lay in wait" for that passing cloud, that fleeting burst of sunlight, that moving shadow. Having caught it, Monet would quickly transfer it to the canvas with a few deft brushstrokes.

One of Monet's "hunting grounds" was Fécamp, and in THE SEA AT FÉCAMP, painted in 1881, he perfectly captures the luminous light and muted silvers, grays, and golds that typify the seas and coastal skies of northern Europe. The effect of the rough waves is achieved by his almost scumbling the paint on, and the stormy sky is conveyed with strong diagonal brushstrokes.

In complete contrast is a painting called simply ANTIBES, which Monet visited in 1888. Here, all is peace and calm, for the sea is the blue Mediterranean. X-rays of the canvas have revealed a layer of freely applied paint beneath the tighter, more precise flecks on the surface, suggestive of wind-ruffled water.

FIELD DAY

When Monet began his extensive series of paintings of haystacks in 1890, he did not have to go far to find his subject matter—the stacks stood in a field nearby his garden at Giverny, and would probably have been visible from the boundary wall. Although earlier works may have anticipated the series, Monet himself felt that it marked a new departure in his painting.

In the series, Monet painted the same subject—one or more haystacks in a field—over and over again, in every kind of weather, at different times of the day and at different seasons of the year. What fueled this theme was his obsession with the combined effects of the changing light and weather, and the variations are therefore endless: there are haystacks painted at sunset, in the morning, in snow, covered with frost, at the end of summer, and so on.

What Monet was really concerned with here was not the stacks themselves, but the atmosphere that shrouded them, that combination of quality of light and quality of air, both of which vary depending on the time of day and the weather. Monet evocatively described this visual phenomenon as the atmospheric envelope. In the paintings, he was preoccupied with an overall color harmony, as if he were seeing everything before him through a unifying veil of color. Because they repeatedly show the same subject under different atmospheric conditions, Monet said that the value of a single picture in the series could only be judged when seen with all the others.

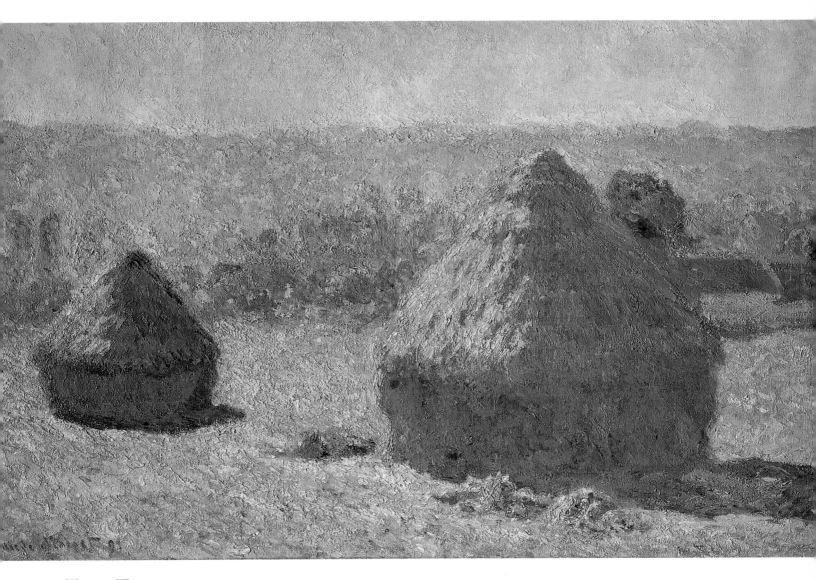

Monet

HAYSTACKS, END OF SUMMER 1891 (above)

HAYSTACKS AT SUNSET, FROSTY WEATHER 1891 (opposite)

GLORIES OF NATURE 87

SNOW SCENES

Like Monet, Alfred Sisley concentrated on landscape painting. In SNOW AT VENEUX-NADON, painted c.1880, one can see the Impressionist obsession with atmosphere and light. This painting has all the suppressed luminosity that typifies a snowy winter's day. The sky glows through a bank of cloud, rendered in scumbled mauves, green-blues, and yellows, while the snow reflects back the light from the sky.

One of the core group of Impressionists, Sisley was born in Paris in 1839, to British parents. He studied under Gleyre, at whose studio he met Renoir and Monet. The group of students found Gleyre's tuition stifling, and in 1863 began to paint together *en plein air*. They traveled to various places along the Seine and around the outskirts of Paris in search of subject matter.

Sisley came from an affluent family and was wealthy in comparison with his two colleagues. However, when his businessman father was ruined during the Franco-Prussian War and died in 1871, Sisley was left with no money and faced the prospect of having to earn a living from his painting.

Sadly, Sisley never achieved the success of some of his colleagues. Years of privation and artistic obscurity left their mark and, in his old age, Sisley became increasingly isolated and mistrustful of others. When he died on January 29, 1899, poor and relatively unrecognized, he did not know the final irony to come—within a year of his death his paintings would begin to fetch fabulous prices.

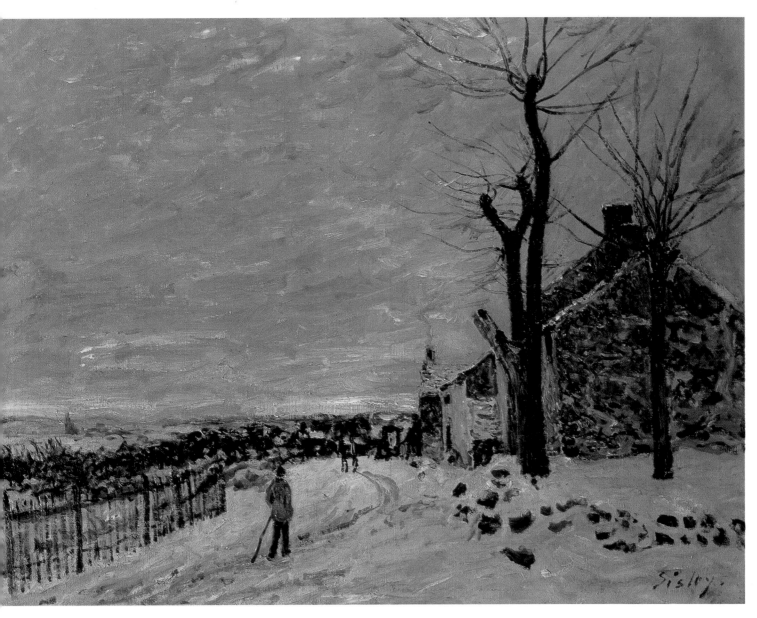

Sisley SNOW AT VENEUX-NADON c.1880

GLORIES OF NATURE 89

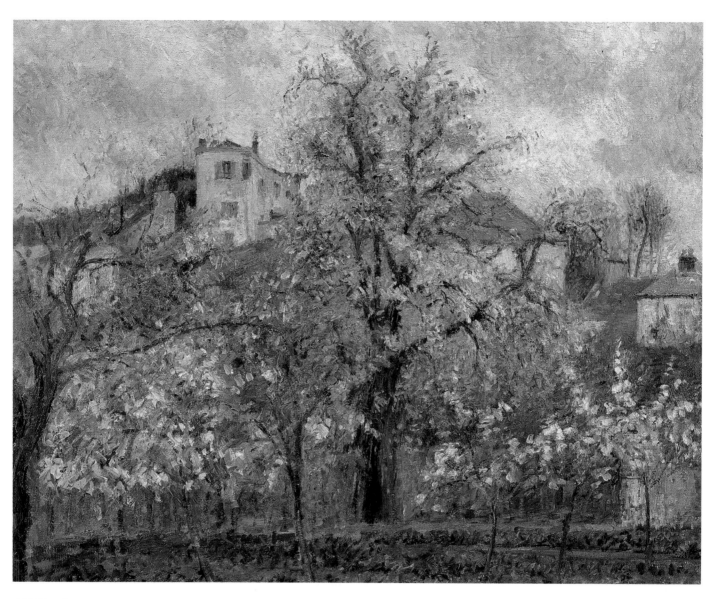

Pissarro SPRING, PONTOISE 1877

90 GLORIES OF NATURE

SPRING BLOSSOM

Pontoise, north of Paris, with its houses, gardens, orchards, and surrounding countryside, provided Pissarro with material for many of his paintings. The artist lived there from 1866 to 1868 and again from 1872 to 1884, after the upheavals of the Franco-Prussian War of 1870–71 and the Paris Commune of 1871, during which he and his family had sought refuge—first in Brittany and then in London.

One of the paintings from this latter period is SPRING, PONTOISE, dated 1877. It shows a charming scene of a burgeoning vegetable and fruit garden, with trees in a froth of white blossom. The atmosphere of the soft spring day is conveyed using dabs of pure color—Pissarro never forgot the advice of Corot, who told him to paint directly from nature and to observe light and tonal values. (Interestingly, Cézanne, who spent part of 1877 at Pontoise painting side by side with Pissarro, did a painting of exactly the same subject.)

The idyll of Pontoise that Pissarro's paintings present belies the reality. Like Monet, Renoir, and Sisley, Pissarro had no private income to subsidize his art, and he was dogged by debts and poverty. His works were selling for less than before—a year after SPRING, PONTOISE was finished, nine canvases put up for sale fetched only 404 francs, including one that sold for the derisive amount of 7 francs. In addition, his wife was pregnant with their fourth child. Such was the burden that in 1878 Pissarro considered giving up painting altogether to try to earn a living another way.

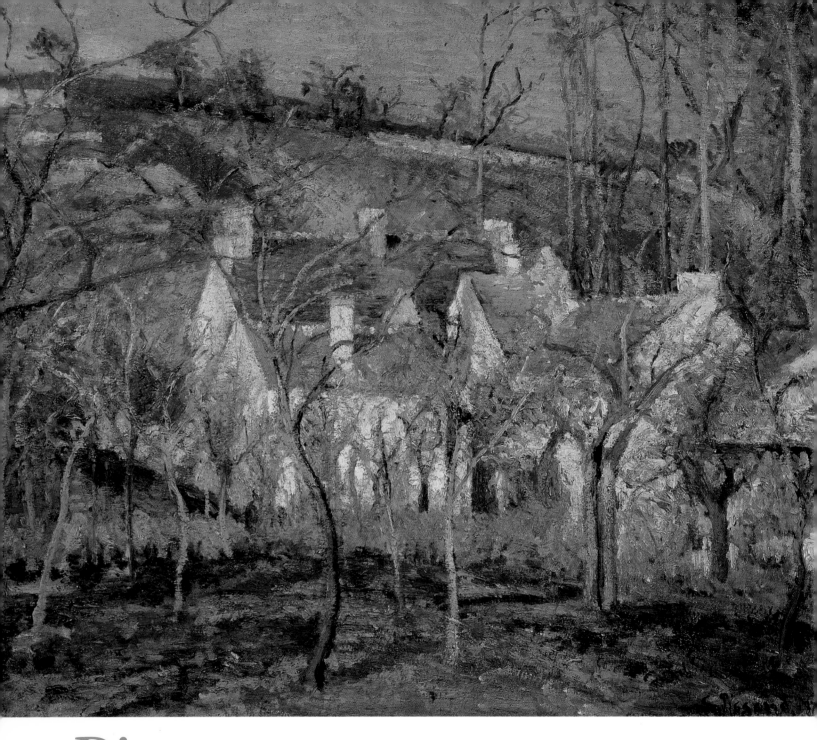

Pissarro

RED ROOFS 1877 (above); THE CÔTE DES BEOUFS
AT THE HERMITAGE, POINTOISE 1877 (opposite)

THE GEOMETRY OF NATURE

The late 1870s marked a particularly difficult time for Pissarro. Discouraged by critical failure and struggling financially, he suffered a near-breakdown and a crisis of confidence, questioning where he was going with his art—or, indeed, if he should go on with it at all.

It was during this time, in 1877, that Cézanne came to work with him at Pontoise, and his influence may have stimulated new concerns in Pissarro's paintings, such as, in THE CÔTE DES BEOUFS AT THE HERMITAGE, PONTOISE, dated 1877. In this relatively large painting, the format is strongly vertical, with a grid of upright trees cutting across the horizontals of the rooftops and the small hill in the background. The geometric composition is worked in thickly tex- tured paint, and the restricted range of tonal values achieves the effect of flatten- ing the image.

Of course, the influence was not one way, and Cézanne later acknowledged his debt to Pissarro, referring to him as "humble and colossal" and affixing to his own name the title "pupil of Pissarro."

For Pissarro, the search for new mean- ing in his art continued into Pointillism, a technique of applying tiny dabs of pure color side by side to optically produce another hue. After a few years, he abandoned the tech- nique because it inhibited his spontaneity.

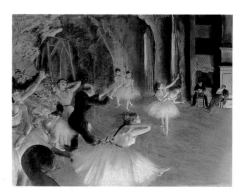 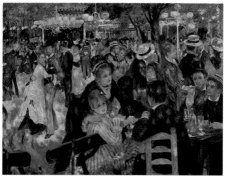 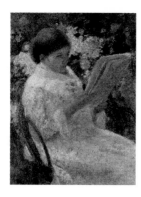

Degas THE REHEARSAL OF THE BALLET ON STAGE **1873–4**

Renoir LE MOULIN DE LA GALETTE **1876**

Cassatt WOMAN READING IN A GARDEN **1880**

EDGAR DEGAS

Edgar Degas was born Hilaire Germain Edgar de Gas in Paris on July 19, 1834. At the age of eleven, two years before his mother died, he began to board at the elite Lycée Louis-le-Grand. In 1853 he studied law briefly but abandoned it for art, enrolling in the studio of Louis Lamothe, a former pupil of Ingres. From 1855, he spent a brief period at the École des Beaux Arts in Paris, before leaving for Italy to pursue his studies independently.

On returning to France in 1859, he at first painted large-scale historical subjects then felt to be the most suitable subject matter for art, but his friendship with Manet, whom he had met in the Louvre in 1862, and his introduction to other artists at the Café Guerbois, completely changed the course of his career (which was interrupted by the Franco-Prussian War of 1870–71, during which he served in an artillery unit).

Although not strictly an Impressionist—he did not paint in the open air, he was not interested in the transient effects of light, and landscape bored him—Degas did exhibit with the group, and helped organize their exhibitions. Like them, too, he was a radical, continually experimenting and exploring. As well as oils, he mastered pastels—a then-unpopular medium, produced prints, and also modeled in clay and wax.

He died on September 27, 1917, virtually blind, at the age of eighty-three.

PIERRE AUGUSTE RENOIR

Pierre Auguste Renoir was born in Limoges on February 25, 1841, where his father was a tailor and his mother a seamstress. In 1845, the family moved to the Rue d'Argenteuil in Paris.

Renoir found his first outlet for his emerging artistic talents when, in 1854, he was apprenticed as a porcelain painter. His obviously considerable ability earned him the nickname "Monsieur Rubens," and his parents, with grave misgivings, agreed to his attending the École des Beaux-Arts instead, for which the young Renoir had saved enough money. He studied there from 1862 and also frequented the studio of Charles Gleyre, where he met Monet, Sisley, and Bazille, all of whom would influence his work. He also met Pissarro and Cézanne. Older influences included Courbet, Corot, and Diaz, who fueled Renoir's passion for painting out-of-doors.

Renoir was a pioneer of Impressionism, while developing his own, highly distinctive style. His career was interrupted by the Franco-Prussian War of 1870–71, when he served in the cavalry. In 1890 he married Aline Charigot, his sons Pierre, Jean, and Claude (Coco) being born in 1885, 1893, and 1901, respectively. In 1900, he was awarded the Légion d'Honneur. Despite being crippled by arthritis and confined to a chair, he painted to the very end. He died at Cagnes in the south of France on December 3, 1919.

MARY STEVENSON CASSATT

Mary Stevenson Cassatt was born on May 22, 1844, in Allegheny City, now a part of Pittsburgh, Pennsylvania. Her father, Robert Simpson Cassatt, made his money in real estate and stock brokerage, and had been mayor of Allegheny City.

Mary's early years saw frequent travel. When she was five, the family moved to Philadelphia; two years later they crossed the Atlantic and spent a couple of years in Paris before moving on to Heidelberg, Germany, and then to Darmstadt in order to further the engineering career of her brother Aleck. When another brother, Robert, died in Darmstadt, the family returned to Philadelphia.

In 1861 Mary enrolled at the Pennsylvania Academy of Fine Art, where she spent four years. In 1866 she moved to Paris, where she studied independently, copying the Old Masters and sketching in the countryside. In 1870, the Franco-Prussian War sent her back home to Philadelphia, but she finally settled back in Paris in 1874.

Probably the greatest influence on her work was Degas, who was both her friend and mentor. Although Mary had a painting accepted by the Paris Salon 1872, and every year for the next four years, her meeting with Degas encouraged her to turn her back on Salon art to join the Impressionists (although she preferred the term Independents). Like Degas, her later years were also burdened with failing eyesight. She died in Paris in 1926.

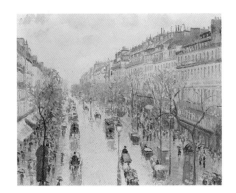

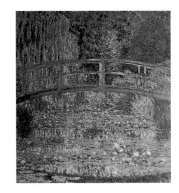

Pissarro THE BOULEVARD
MONTMARTRE **1893**

Monet THE WATERLILY POND: GREEN
HARMONY **1899**

CAMILLE PISSARRO

Of French-Jewish parentage, Camille Pissarro was born on July 10, 1830, on St. Thomas, one of the Virgin Islands. When old enough, he worked as a clerk in his father's general store but spent the rest of his time sketching. His parents finally agreed to let him study art after he had run away to Venezuela with an artist acquaintance—and in 1855, the 25-year-old arrived in Paris (where he had earlier spent time at school). Here he worked in various studios, at the academic École des Beaux-Arts and at the Académie Suisse, where he met Monet and Cézanne. He also studied under Corot, who always stressed the importance of an artist capturing the first impression.

In 1858, his parents had come to live in Paris, where he met his future wife Julie Vellay, then his mother's maid. The couple married in 1870 in London, and they had seven children.

Meanwhile, after an initial period painting landscapes that were exhibited by the Salon during the 1860s, Pissarro joined with Monet, Renoir, and Sisley to develop the Impressionist style. Later, under the influence of Seurat and Signac, he would experiment with Pointillist theories before returning to his original Impressionist concepts. Always kind and patient, he was a natural teacher—according to Mary Cassatt, Pissarro could have taught stones how to draw. He died in November 1903, at the age of seventy-four.

CLAUDE OSCAR MONET

Claude Oscar Monet was born November 14,1840 in Paris, the son of a wholesale grocer. When he was five, the family moved to Le Havre where he acquired a reputation as a caricaturist. In 1862 his father allowed him to go to Paris to study art under Charles Gleyre. Here he was to meet Bazille, Pissarro, and what were to be two lifelong friends, Renoir and Sisley.

Around 1865, Monet began a relationship with Camille Doncieux who, in 1867, bore their first son, Jean. In 1870, the couple married but fled the Franco-Prussian War to London. Back in France in 1871, they set up home at Argenteuil.

Monet's finances were always uncertain, and a friendship formed in the mid-1870s with Ernest Hoschedé, a wealthy businessman and art lover, looked promising. Unfortunately, Hoschedé went bankrupt in 1877, leaving his wife Alice and their children with the Monets. In 1878, the two families moved together to Vétheuil. Camille had recently given birth to a second son, Michel, but subsequent ill-health led to her death in 1879.

In 1881, Monet and Alice Hoschedé moved to Poissy, and in 1883 to Giverny. In 1892, after Ernest had died, they were free to marry. Of all Monet's homes, Giverny is the most famous. In 1911 Alice died, but despite failing eyesight he continued with his monumental Water Lily series. He died at Giverny on December 6, 1926.

ÉDOUARD MANET

Édouard Manet was born in Paris in 1832. He had studied at the École des Beaux-Arts between 1850 and 1856 before an honorable recognition at the 1861 Salon, before becoming a subject of heated controversy with his LE DÉJEUNER SUR L'HERBE at the Salon des Refusés of 1863.

His biggest formative influence was Spanish art—he once declared Velasquez "the painter of painters"—before falling under the spell of the Impressionists, and although he never exhibited with them he was really important, along with Courbet, as their predecessor.

In 1882 he was appointed Chevalier de la Légion d'Honneur, but he remained bitter and cynical about this recognition relatively late in his career; he died the following year.

BERTHE MORISOT

Born in 1841, Berthe Morisot studied at the École des Beaux-Arts from1856 to 1859, and then from 1860 under the classical French painter Camille (Jean-Baptiste) Corot.

Her painting THE CRADLE (1873) was shown at the first Impressionist exhibition in 1874, and she subsequently had her work exhibited in seven out of the eight Impressionist exhibitions that followed., Her sensitive approach influenced Manet, who was her brother-in-law, during the 1870s. She died in 1895.

Acknowledgments

Front Cover Bridgeman Art Library, London/New York/Christie's Images. **Back Cover** Bridgeman Art Library, London/New York/Christie's Images. **Front and Back Endpaper** Bridgeman Art Library, London/New York/Christie's Images. **frontispiece tracing** AKG, London/Museum of Fine Arts, Houston. **3** AKG, London/Museum of Fine Arts, Houston, Texas. **4-5** Bridgeman Art Library, London/New York//Giraudon/Musee D'Orsay, Paris. **7** Bridgeman Art Library, London/New York/Christie's Images. **8** AKG, London/Ordrupgaardsamlingen, Copenhagen. **10-11** Bridgeman Art Library, London/New York/Phillips Collection, Washington DC, USA. **12** Corbis UK Ltd/Francis. G. Mayer. **13** Corbis UK Ltd/Francis G. Mayer. **14** AKG, London/Musee des Beaux Arts, Lyon. Eric Lessing. **15** AKG, London/Courtauld Institute Galleries. **16** Bridgeman Art Library, London/New York/Metropolitan Museum of Art, New York, USA. **16-17** tracing Hulton Getty Picture Collection. **17** Bridgeman Art Library, London/New York/Metropolitan Museum of Art, New York, USA. **18** Bridgeman Art Library, London/New York/National Gallery, London. **19** Bridgeman Art Library, London/New York/National Gallery, London. **20** Corbis-Bettmann. **21** Bridgeman Art Library, London/New York/Courtauld Gallery, London. **22** Corbis UK Ltd/Francis G. Mayer. **23** Bridgeman Art Library, London/New York/National Gallery of Art, Washington DC, USA. **24** Bridgeman Art Library, London/New York/Musee d'Orsay, Paris, France,Peter Willi. **25** Bridgeman Art Library, London/New York/National Gallery, London, UK. **26** AKG, London/Musee d'Orsay, Paris, Erich Lessing. **27** Corbis UK Ltd/Alexander Burkatowski. **28-29** Bridgeman Art Library, London /New York/Musee d'Orsay, Paris, France/Peter Willi. **31** Bridgeman Art Library, London/New York/Giraudon/Musee d'Orsay, Paris, France. **32** AKG, London/Musee d'Orsay, Paris. **32-33 tracing** Hulton Getty Picture Collection. **33** Bridgeman Art Library, London/New York/Giraudon/Musee d'Orsay, Paris, France. **34** Bridgeman Art Library, London/New York/Musee d'Orsay, Paris, France. **35** AKG, London/Musee d'Orsay, Paris. **36** Bridgeman Art Library, London/New York/Metropolitan Musuem of Art, New York, USA. **38** Bridgeman Art Library, London/New York/Musee d' Orsay, Paris, France/Peter Willi. **39** Bridgeman Art Library, London/New York/Giraudon, National Gallery of Art, Washington DC, USA. **40** Bridgeman Art Library, London/New York/Neue Pinakothek, Munich, Germany. **41** Bridgeman Art Library, London/New York/Neue Pinakothek, Munich, Germany. **42-43** Bridgeman Art Library, London/New York/National Gallery, London, UK. **44** AKG, London/Musee du Louvre, Paris. Erich Lessing. **45** Bridgeman Art Library, London/New York/Metropolitan Museum of Art, New York, USA. **46** Bridgeman Art Library, London /New York/Giraudon/Musee du Petit Palais, Paris, France. **47** Bridgeman Art Library, London/New York/National Museum and Gallery of Wales, Cardiff. **48** Corbis UK Ltd/Francis G. Mayer. **48-49 tracing** Smithsonian Institution/Archives of American Art, Frederick A. Sweet Papers. **49** Corbis UK Ltd/Francis G. Mayer. **50** AKG, London/Musee d'Orsay, Paris. Erich Lessing. **52** AKG, London/H. O. Havemeyer Collection, Metropolitan Museum of Art, New York. Erich Lessing. **53** Bridgeman Art Library, London/New York/National Gallery of Art, Washington DC, USA. **54-55** AKG, London. **56** Bridgeman Art Library, London/New York/Musee Marmottan, Paris, France/Peter Willi. **57** Bridgeman Art Library, London/New York/Musee Marmottan, Paris, France/Peter Willi. **58** AKG, London/Musee d'Orsay, Paris. Erich Lessing. **59** Bridgeman Art Library, London/New York/Pushkin Museum, Moscow, Russia. **60** Bridgeman Art Library, London/New York/Bulloz/Musee d'Orsay, Paris. **61** Bridgeman Art Library, London/New York/Musee Marmottan, Paris, France/Peter Willi. **62-63** AKG, London/Pushkin Museum, Moscow. **63** right AKG, London/Larock Granoff Collection, Paris. **64** Bridgeman Art Library, London/New York/Christie's, Images, London, UK. **64-65 tracing** Octopus Publishing Group Ltd./Louvre, Paris. **65** Bridgeman Art Library, London/New York/Christie's Images, London, UK. **66** Bridgeman Art Library, London/New York/Brooklyn Museum of Art, New York, USA. **67** AKG, London/Musee des Beaux Arts, Lyons. **68** Bridgeman Art Library, London/New York/Giraudon, Musee d'Orsay, Paris. **69** Bridgeman Art Library, London/New York/Giraudon/Musee d'Orsay, Paris. **70** Bridgeman Art Library, London/New York/Musee D'Orsay, Paris, France/Peter Willi. **71** Bridgeman Art Library, London/New York/Musee D'Orsay, Paris, France/Peter Willi. **72** AKG, London/Musee d'Orsay, Paris, France/Erich Lessing. **74** Bridgeman Art Library, London/New York/National Gallery, London, UK. **75** Bridgeman Art Library, London/New York/National Gallery, London, UK. **76-77** AKG, London/Musee d'Orsay, Paris. Erich Lessing. **78** Bridgeman Art Library, London/New York/Giraudon/Musee d'Orsay, Paris, France. **79** Bridgeman Art Library, London/New York/Musee d'Orsay, Paris, France/Peter Willi. **80** Bridgeman Art Library, London/New York/Musee D'Orsay, Paris, France. **80-81 tracing** Hulton Getty Picture Collection. **81** Bridgeman Art Library, London/New York/Musee d'Orsay, Paris, France. **82** Bridgeman Art Library, London/New York/Christie's Images, London, UK. **83** Bridgeman Art Library, London/New York/Christie's Images, London, UK. **84** Bridgeman Art Library, London/New York/Courtauld Gallery, London, UK. **85** Bridgeman Art Library, London/New York/Private Collection. **86** Bridgeman Art Library, London/New York/ Private Collection. **87** AKG, London/Musee d'Orsay, Paris. **89** Bridgeman Art Library, London/New York/Musee d'Orsay, Paris, France. **90** Bridgeman Art Library, London/New York/Giraudon/Musee d'Orsay, Paris, France. **92** Bridgeman Art Library, London/New York/Giraudon/Musee d'Orsay, Paris, France. **93** Bridgeman Art Library, London/New York/National Gallery, London, UK. **94** Top Left Bridgeman Art Library, London/New York/Metropolitan Museum of Art, New York, USA. **94** Top Centre AKG, London/Musee d'Orsay, Paris. **94** Top Right Corbis UK Ltd/Francis G. Mayer. **95** Top Left Bridgeman Art Library, London/New York/Christie's, London. **95** Top Centre Bridgeman Art Library, London/New York/Musee d'Orsay, Paris, France. **96** Bridgeman Art Library, London/New York/Musee d'Orsay, Paris.

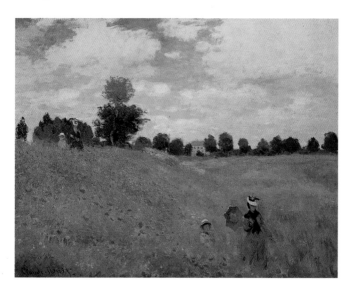

Monet WILD POPPIES, NEAR ARGENTEUIL 1873